Fresh Dialogue Two:
New Voices in Graphic Design

Princeton Architectural Press
American Institute of Graphic Arts New York Chapter

New York

Fresh Dialogue Two

Kevin Lyons

one9ine

ReVerb

Published by
Princeton Architectural Press
37 East 7th Street
New York, New York 10003

For a free catalog of books, call 1.800.722.6657.
Visit our web site at www.papress.com.

Editing: Nancy Eklund Later
Series design: Sara E. Stemen
Cover design: Deb Wood

Special thanks to: Nettie Aljian, Ann Alter, Amanda Atkins, Nicola Bednarek,
Janet Behning, Penny Chu, Jan Cigliano, Jane Garvie, Tom Hutten, Clare Jacobson,
Mark Lamster, Linda Lee, Anne Nitschke, Evan Schoninger, Lottchen Shivers, and
Jennifer Thompson of Princeton Architectural Press—Kevin C. Lippert, publisher

Library of Congress Cataloging-in-Publication Data
Lyons, Kevin, 1969-
Fresh dialogue two : new voices in graphic design / Kevin Lyons &
Warren Corbitt & Susan Parr.
 p. cm.
 ISBN 1-56898-264-X (alk. paper)
1. Commercial art—New York (State)—New York. 2. Graphic arts—New
York (State)—New York. 3. Designers–New York (State)—New
York—Interviews. I. Title: Fresh dialogue 2. II. Corbitt, Warren,
1970- III. Parr, Susan, 1959- IV. Title.
NC998.5.N72 N485 2001
741.6'092'27471—dc21 2001003813

Table of Contents

Introduction

May 10, 2000, marked the eighteenth annual presentation of Fresh Dialogue by the New York chapter of the AIGA. Devoted to exploring fresh perspectives on design, the series provides the New York design community with an opportunity to hear emerging voices within the field and to compare and contrast designers' visions for the future. There is a maverick spirit to the event, both because the speakers are often new to this audience and because their work tilts toward the experimental.

This year's Fresh Dialogue occurred in the midst of a renaissance. Design has become a force of immense strategic and economic importance that has profoundly affected the culture. As the public has become more educated about design, it expects a more adventurous spirit from designers. In response, the business community has begun to place ever more emphasis on the designer's ability to analyze culture and shape communications. It is now necessary for anyone interested in reaching a sophisticated audience to seek the deeper level of interpretation offered by good design.

Fresh Dialogue tackled all of this head-on. This year's event was organized by designer Barbara Glauber, a previous Fresh Dialogue presenter. She selected the participants—Kevin Lyons, one9ine partners Warren Corbitt and Matt Owens, and Susan Parr of ReVerb—for their unique approaches to form-making and for the intensity of their personal visions. Although vastly different in method and style, the work of the presenters sits on the cutting edge of design.

Kevin Lyons, an intuitive and improvisational designer, floats his signifiers into the ether, watching them land with stunning precision. His work for Urban Outfitters is so clearly attuned to the clothing company's market, it almost redefines the word hip. The visible process in Lyons' work—its layering, rough edges, and handwritten typography—gives it the appearance of simple doodling, but it all hangs together too well for that. By relying on appropriation, juxtaposition, and humor, Lyons translates the vernacular into his own voice. He has brought street credibility to commerce and forged a radical new definition of branding.

Warren Corbitt and Matt Owens of one9ine have embraced the recent technological direction of design, but their innovative style also belies a deep commitment to traditional design values. They are equally adept at making classically resolved, almost sensual design within a technological format and incorporating technological signifiers within a traditional format. Committed to applying what they've learned through personal exploration to their projects for clients such as Nike and the Museum of Modern Art, they create work that is simultaneously dimensional, narrative, and simply beautiful.

The final presenter, Susan Parr, showed the work of ReVerb, a West Coast design group that really goes under the hood to dissect the nature of a design problem. Through an approach that blends research, business strategy, and intelligent design, the firm arrives at unique solutions to branding and positioning products. With clients such as IBM and Hewlett-Packard, they've brought an in-depth understanding of culture to the traditional business world.

In an effort to recreate the spirit of the evening, three new (read fresh) dialogues are presented here in the form of interviews with each presenter. Weston Bingham, a creative director at marchFIRST, talks to Kevin Lyons; AIGA editorial director Andrea Codrington, visits with Warren Corbitt and Matt Owens of one9ine; and Bret Wickens, vice-president, Experience Design, at Sapient, speaks with Susan Parr, along with her fellow founding partners and collaborators at ReVerb, Somi Kim and Lisa Nugent. I think you will find these conversations, and the work that accompanies them, both illuminating and provocative.

Janet Froelich
President, AIGA NY

SHOOTIN' THE SHIT
SOUND SYSTEM PROVIDERS
SQUAWK BOXES
SWAPPING STORIES
WHITE LIES AND
ALIBIS
FALSE PROPHETS
SOOTHSAYERS
LOUDMOUTH HYPOCRITES
SOAPBOX PREACHER
SPITTING SYLLABLES

MICROPHONE FIENDS
CHEWING THE FAT
GIFT OF GAB
BRING THE VOCAB
VERBAL ATTACKS
SOUNDBITES
SNIGLETS

TALKING HEADS
TALL TALES
TONGUE TWISTER
HE SAID SHE SAID
RHYME DELIVERY
RANTIN' AND RAVIN
DISHING DIRT
RELEASING VERBS
IDLE CHATTER
AS ALL PRAISE DUE
PUBLIC SERVICE
ANNOUNCEMENT
SPEAKING TONGUES
SPREADING RUMOURS
TRASH TALKIN'
SERVIN' UP PHRASES
AND SMOOTH TALKERS
WORDS THAT I MANIFEST
SINGING PRAISES
ILL COMMUNICATION
AND
FRESH DIALOGUE
KEVIN LYONS
SUSAN PARR
OF REVERB
ONE9INE

Kevin Lyons

Interviewed by Weston Bingham
Caffe Della Pace
48 East 7th Street
New York, New York
October 23, 2000
6:30 PM

BINGHAM

In terms of your recent design outlets—
Urban Outfitters, *Tokion* magazine, the web
site Natural Born, and the collaborative
fashion work you do with SSUR—what sort
of explorations does each allow for?

LYONS

Well, I would separate Urban Outfitters from
the others, only because I'm acting as an art
director for them. I think what I do freelance
informs how I direct the Urban Outfitters
Art Department, but I keep the two very
separate.

This is my first position as art director,
and my first inclination was to channel the
work to look like my own. When I draw an
illustration for use at Urban Outfitters, I'll
get one of the designers I collaborate with
there to redraw it, in an effort to separate
my own work from work that I art direct.

BINGHAM

Why would you not want your work for
Urban Outfitters to look like your own?

LYONS

For two reasons. One is because Urban
Outfitters speaks to a different crowd than
I speak to with my personal work. It has a
specific customer, a specific world in which
that design work lives. The other, quite
honestly, is that if Urban Outfitters looks like
my own work, there's not a lot of me to sell
outside of Urban Outfitters. I want to keep
my work extremely vibrant and new to people.
I don't want people hiring me and asking me
to do Urban Outfitters-style work.

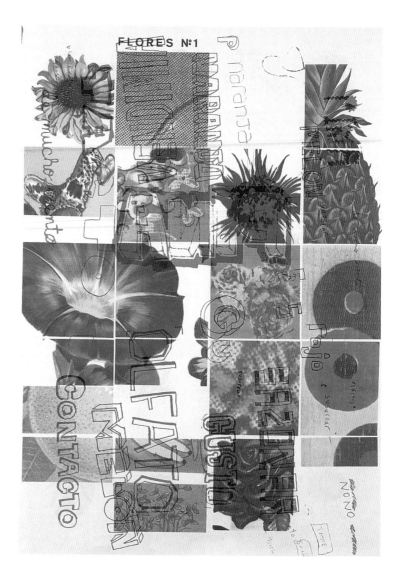

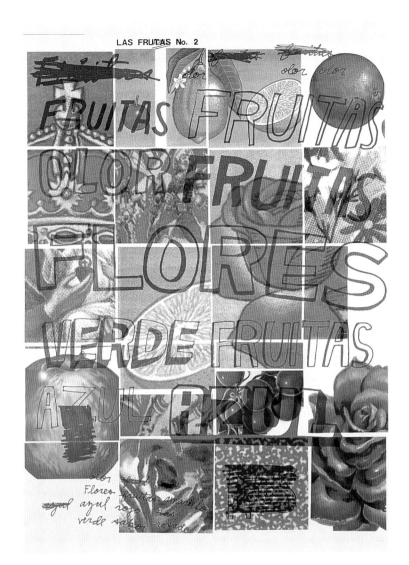

LAS FRUITAS No. 2

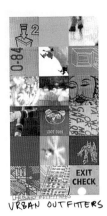

URBAN OUTFITTERS

BINGHAM

What about *Tokion*, Natural Born, and SSUR?

LYONS

All of those have really been attempts to
establish my own style of work. When I
moved back to New York from California and
was freelancing, people would ask me to do
work for them and it's like being told, "I
really like this type of work and I need you
to carry out this project for me in this way."
And having observed other designers and
the success that they were having, I realized
that my work was getting lost. No one really
knew what my work was. *Tokion*, Natural
Born, and SSUR have all been attempts to
develop some sort of a style, so that when
people come to me they want what I'm
doing, so they hire me for me, so that clients
aren't dictating what I do as a designer.
Before I moved back to New York, I was often
being dictated to, and I was happy with that,
because I was designing and making money.
These projects have been attempts to
develop some sort of style that people
would recognize as Kevin Lyons, separate
from just carrying out a job. It would be this
other thing.

BINGHAM

Presumably, you had to show the work that
you'd been doing, either before CalArts or
at CalArts, to Urban Outfitters in order to
actually get the job as art director. From
their point of view, they were hiring you to do
the kind of work that was in your portfolio.
Do you think that you're holding back, that
you aren't actually giving everything you
might give for clients like SSUR or *Tokion*,
because the audience is maybe less . . .
authentic?

LYONS

I wasn't trying to imply that. I was trying
to say that at Urban Outfitters, I have five
other designers working with me, so it's
much more of a collaborative effort. The
only reason I might hold back from Urban
Outfitters is, in a sense, to allow others to

MOOKS/TOKION 1999
CUT AND SEWN T-SHIRTS / ONE COLOR GOLD FOIL.
GOLD CHAIN GRAPHIC BLEEDS OFF SEAM / APPLIED TO PANEL BEFORE SEWING
MEN'S AND WOMEN'S AVAILABLE IN BOTH RED AND NAVY ONLY
IN LA AT NYSC&SUBURBAN / IN SF AT VILLAINS / IN NYC AT YELLOW RAT BASTARD &SWISH
OR SEND 34 BILLS TO KNEE HIGH MEDIA US 939 1/2 CHUNG KING RD. LA CA 90012

COMMON SENSE & PROPER GANDA
LIMITED EDITION SSUR/TOKION TSHIRTS AVAILABLE EXCLUSIVELY AT
SSURPLUS 219A MULBERRY ST. EMPIRE STATE P.212-431-5132 / F.212-431-5163
OR SEND US $30.00 CHECK OR MONEY ORDER TO: KNEE HIGH MEDIA US. 939 1/2 CHUNG KING RD. LOS ANGELES CA 90012

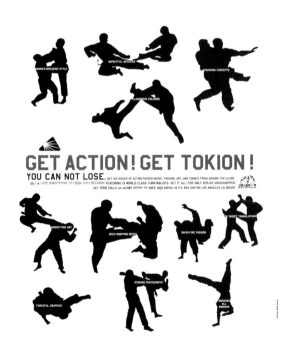

GET ACTION! GET TOKION!
YOU CAN NOT LOSE.

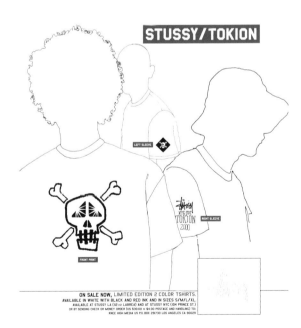

STUSSY/TOKION

ON SALE NOW, LIMITED EDITION 2 COLOR TSHIRTS.
AVAILABLE IN WHITE WITH BLACK AND RED INK AND IN SIZES S/M/L/XL.
AVAILABLE AT STUSSY LA (112 1/2 LABREA) AND AT STUSSY NYC (104 PRINCE ST.)
OR BY SENDING CHECK OR MONEY ORDER (US $30.00 + $4.00 POSTAGE AND HANDLING) TO:
KNEE HIGH MEDIA US P.O. BOX 29730 LOS ANGELES CA 90029

have a voice, because as an art director you're balancing everyone's opinions. You have to scale down you. You can't do a full-on you. The other designers should have as much say in what's going on as I do.

In no way have I ever backed off from Urban Outfitters. Unfortunately, it's almost dominated what I've been doing over the last year and a half. I've done less design and more art direction. I only said the part about the salability of my own work because, as a designer, I feel that you always have to protect what's personally yours, because your job is not going to be your job for life. Your job is not you.

BINGHAM
Maybe that was a bad question.

LYONS
No, I think that was a good question. To go back for a second, I think the interesting part—the best part—about being an art director has been the collaboration. It's like, when do you step in and when do you step back? When do the voices of the people you work with come through, and when does it need to be your voice? How responsible are you for what's happening within the studio? I think that I've always been stronger talking about other people's work. I always kind of know in my mind where the work should be going, no matter whose it is; maybe less so when it's my own work. Maybe that's true for everyone.

BINGHAM
What about the collaboration with SSUR? Is that more of an art outlet?

LYONS
It's more of an outlet. SSUR is what I truly enjoy doing. And Natural Born, because Natural Born is even more me than even SSUR. Even though I'm doing all this corporate work, I still have this little world that's always open to me where I can create what I want to create. It's really just a personal outlet.

ANTHROPOLOGIE

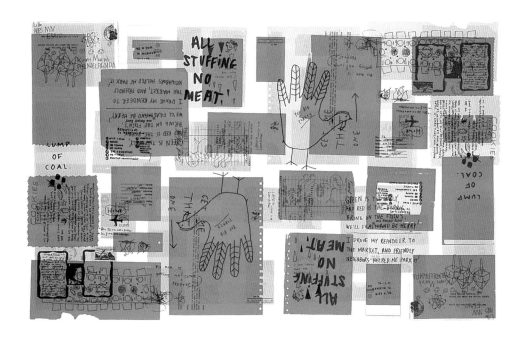

I think that what happens with young graphic designers is that you feel like you have to make an artistic statement and work for clients at the same time. For me, I've always had this other, outside thing that has allowed me to make a personal statement. I don't have to put all the pressure on my work. I don't have to go into every project thinking I also have to make a bold statement in this piece. I can make good design, I can have fun with it, but it's not the entire embodiment of my work.

BINGHAM

Let's talk about branding for a minute. While the work that you've done for Nike is an integral part of the larger Nike juggernaut, your reach within Nike's market was finite. The work you do for Urban Outfitters is a complete branding project, but the clients' reach is limited. How does your work fit within the more localized branding efforts of a global corporation, versus the complete branding efforts of a smaller company?

LYONS

That's the irony of corporate design, really. You would think that the bigger you get, the more chances you would take, and Welden & Kennedy, Nike's primary agency, does take a lot of risks. But Nike was run like a conservative company.

The work I did when I was there, though, was very much in the vein of Urban Outfitters. My personal approaches at Nike and at Urban Outfitters weren't that different. The approaches of each company to their own branding are extremely different.

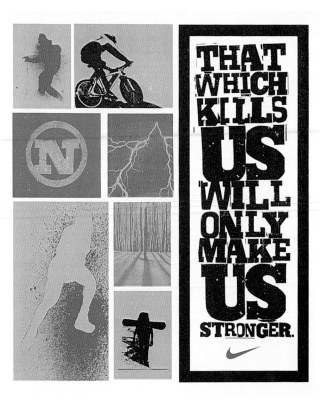

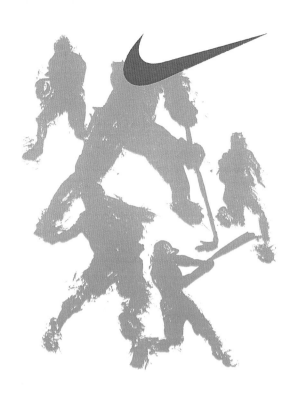

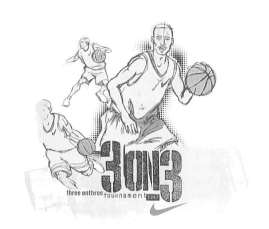

CARVED DELTOIDS BLACK SOX BAGGY SHORTS SHAVED HEADS & BROKEN GLASS.

3 ON 3

three onthree tournament 1997

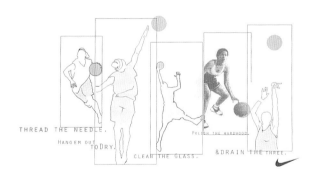

THREAD THE NEEDLE.

HANG EM OUT TO DRY.

POLISH THE HARDWOOD.

CLEAN THE GLASS.

& DRAIN THE THREE.

BINGHAM

What did you do for Nike? What did they expect from the work you did for them?

LYONS

The work I did at Nike was a part of the larger Nike branding mission. The projects I did for Nike after I left, as a freelancer, were aimed at limited groups of consumers, at niche markets, at urban street basketball markets. So I could work much more directly in the style that I usually work in, because the market wasn't that different from the *Tokion* market, or the SSUR market, or the Natural Born market. I've been able to design the way I want to, to put it out on the street.

BINGHAM

Your work in both the larger branding efforts of Urban Outfitters and the niche branding of Nike targets groups of which you are a part. How does the local voice you speak with translate to a global audience?

LYONS

At Nike, you're always conscious that you are part of a larger branding mission, that even the small voices that you create are part of this larger voice, but you still thought about who you're designing for in a narrow way; at least I did. When I was assigned to do a basketball tee targeted for a basketball market, I was thinking of the kids that I knew who played basketball. I was thinking of the very narrow world in which I live. What would those kids respond to? Whether or not Nike picks up on that or it translates to the larger mission is really up to Nike, not me.

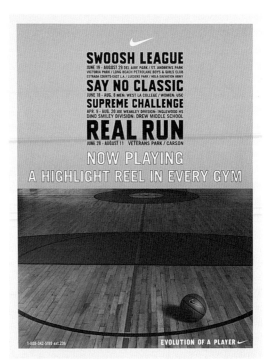

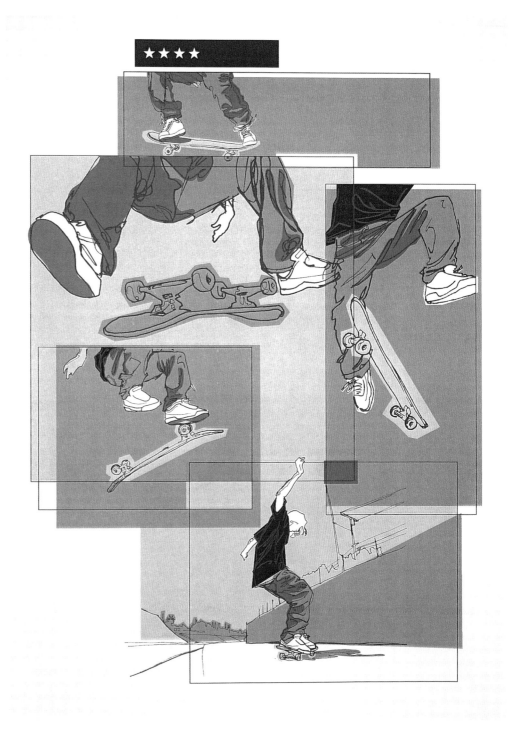

That's probably why I didn't stay there long, because I wasn't really interested in pushing the whole, larger Nike branding mission. There were a few tee-shirts that I did that did massive numbers, if you want to talk in terms of that being success, and then there was tons of work that remained as color printouts. I wasn't making the tee-shirts that would, like, sell world-wide and make fifty million dollars. I was making tee-shirts that were interpreted by Nike as being these authentic messages that would translate to some people, and do marginal sales, and would help authenticate the larger mission statement, I guess.

That's maybe why I was at Nike. It seemed like I was always trying to help authenticate the type play or the vernacular sports designs that had maybe a little less attitude, but a little more commercial appeal. So maybe I was part of that balance.

BINGHAM
You touched on authenticity. High-end fashion designers are selling one-off, spray-painted tee-shirts and Soho boutiques are holding graffiti exhibition in their stores. Urban Outfitters hires you. What happens to the subculture's visual currency when it's stolen by mainstream culture?

LYONS
The most positive thing about when that happens is that it means you now have to dig deeper. I think that any time that Madison Avenue or Seventh Avenue steals from underground culture it just forces that culture to go in a different direction, to evolve into a more complex and more interesting subculture.

I get hired at Urban Outfitters. I'm thirty-one years old now. There are kids out there doing the work I used to do—in a sense, being me back then—and those are going to be the next kids to come up. They'll be the ones to come up with the next cultural icons.

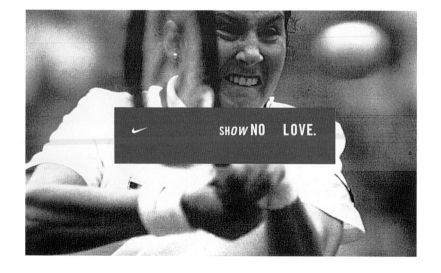

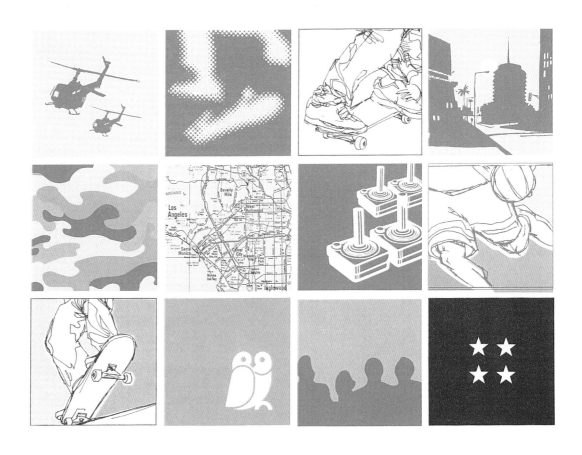

LOS ANGELES

BINGHAM

What's different about the way you use your visual language when you work for brands that are part of the dominant culture than when you work for more underground, niche market brands? Is it fair to use the language you might use for SSUR and Girl Skateboards for Nike?

LYONS

I would never take a piece I did for Girl Skateboards and translate it for Nike. I would approach a Nike job differently.

BINGHAM

So the language you use for a small niche market might not be an appropriate language for the mass market?

LYONS

The bulk of the time, no. It comes down to appropriation. I can rip off a logo, I can rip off a movie poster, or a movie name, or use a photo for SSUR that I could never use for Nike, because legally I could never do it; too many cease and desist orders. Nike tends to be based on something that is more original, while SSUR has to take a more original approach to something that already exists.

BINGHAM

Let's talk about style for a minute. Your work is not necessarily about conceptual problem solving; nor is it simply about surface and form. But you do have recurring content, recurring formal themes. What are the primary themes you deal with?

LYONS

Appropriation. Blatant stealing, calling out something that exists within the world that hasn't been juxtaposed with something else, even for the work I did at Nike.

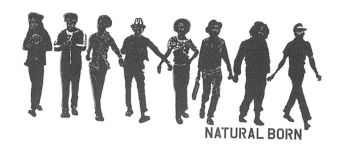

BINGHAM

Even for more commercial clients?

LYONS

Yeah, I still manage to get things in there.

When I started out, I was ripping off Blue
Note album covers and poster designs by
Paul Rand, and that's how I learned graphic
design, by ripping off other people. Most
people learn it that way. I still rely pretty
heavily on appropriation, and that's why a
lot of people claim that my work doesn't
have a lot of style, because it takes on the
style of whatever I'm appropriating. For
instance, a lot of the SSUR stuff has come
from military graphics. I still put my own
spin on it, though. You can recognize my work
by the humor or by the weird juxtaposing
that happens.

BINGHAM

So what's with the Che Ape for SSUR?

LYONS

I didn't come up with the Che Ape. That was
my business partner's, Russell Karablin.
We've always looked at Che as a revolution-
ary, and we both collect toys—*Planet of the
Apes* stuff, and apes in general. Russell put
all these things together and people really
responded to it.

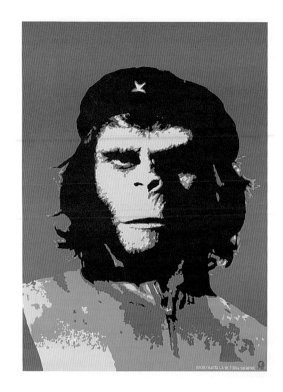

★ IT WILL TAKE FUTURISTIC SOLDIERS TO FIGHT FUTURISTIC WARS SSUR TECH NINENINE TWO GRAND

BINGHAM

If the language of appropriation maintains its value by the viewer's knowledge of the source material, then an appropriated icon has to be known to actually have value. How does that play out in *Tokion*? How do the rip-offs of Che play out for a Japanese pop culture magazine when it is not really a part of Japanese pop culture?

LYONS

It's Japanese style. *Planet of the Apes*, Che, all that stuff; if you go to Japan, you'll see it on the street.

BINGHAM

But is it pop culture as surface, or pop culture with some deeper value?

LYONS

It's a combination, the same as here.

To create a new question out of what you just asked, the challenge now is, can we create new cultural imagery outside of what's really popular? Like, everyone agrees to like Che. People say Che was popular because Che never assumed power. Like, all of these leaders that actually took over the country, like Castro for instance, were Che at one point. Che looked up to Castro, but because Castro assumed the role of leader within a socialist government, people don't like Castro. People love Che.

The challenge for Russell and me has become how to appropriate other cultural phenomena. How do we escape the Che Ape and move forward when everyone wants to buy that. They want it on a glass. They want it on a tee-shirt. How do we interject anything new?

SSUR★PLUS FIELD OFFICE
HDQTRS. 7 SPRING STREET EMPIRE STATE 10012

BLACK OUTLINE

OLIVE FILL

SSUREAL VISUALS 212.431.5375 T

SSUR PLUS
219A MULBERRY ST.
EMPIRE STATE 10012
212. 431. 3152

BINGHAM

It's fine to appropriate from the "power culture"—to use a phrase from something you wrote—when you're not within the power culture, but how does this process translate when you are working within the power culture? You obviously can't steal from Nike when you're at Nike.

LYONS

No, you can't, but you still can. I mean, in some ways, you have to be more clever working within the power culture. Like for Nike, I did a Michael Jordan tee-shirt graphic that relied on appropriation because it directly responded to another athlete. Jordan was retired, and we were looking at doing some new tee-shirts, and we were like, "how do we make Jordan relevant?" We took Alan Iverson, another basketball player who has gold fronts, wears gold chains, wears baggy shorts, has this crazy shoe. I thought, everyone worships Iverson, but Jordan was the original Iverson. So I sort of appropriated the popularity of Alan Iverson, interjected it back into Jordan and made a tee-shirt saying, "Remember who did all these things first. Remember who wore gold chains first, who shaved his head and wore baggy shorts."

At Nike, I also used verbiage that was appropriated from a hip-hop song or from a street saying. There was a tee-shirt that I did that said, "Orange rims no longer parallel to earth." It was specifically meant for the street, for street culture, because in every New York City street basketball court there's an orange rim. So I appropriated it from the immediate culture. Everyone who played basketball in the streets of New York would know what an orange rim was.

REMEMBER WHO WORE BAGGY SHORTS, WITH NO SOCKS, **GOLD CHAINS, AND SHAVED HIS HEAD FIRST.**

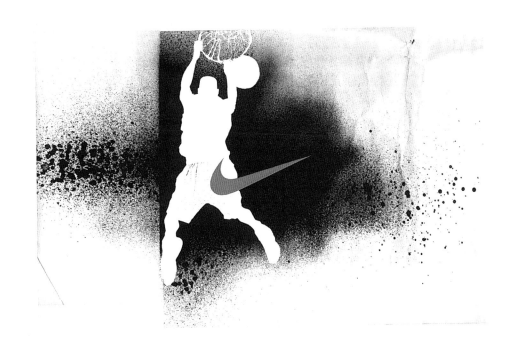

ORANGE RIMS
NO LONGER
PARALLEL TO EARTH

BINGHAM

You mentioned hip-hop. In the past you've drawn parallels between your design work and hip-hop in terms of its process as well as its cultural and political motivations.

LYONS

Yeah, and I still do. But I think that it's a struggle for me every day. Hip-hop as a culture is so much more complex than any design work that's been done about hip-hop, and I include my own work in that. Graffiti played an integral role in hip-hop, it grew from hip-hop, and design has supported hip-hop, but it hasn't really played a part in hip-hop. The underground side of hip-hop doesn't really have access to designers who want to work for them and do really creative stuff. They don't have the money to do an album cover with a crazy gate fold on uncoated stock or stuff like that. And the commercial side of rap music supports bad graphic design. I don't really want to work for the commercial rap world, because I don't want to do neon graphics and put halos over guys and put them in gold coffins with pot leaves around them. It's not really me. So it's a struggle because I always want to be involved with hip-hop. Natural Born is my only interaction with hip-hop now, in terms of what I can do personally to further the culture that has inspired me and my life.

As far as the politics, I feel like my work is similar to hip-hop; that I'm trying to make people aware of things, to use hip-hop as a form of education. But hip-hop for me is how I grew up and how I think.

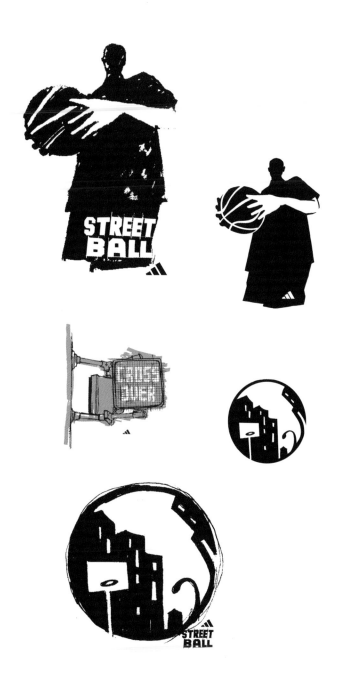

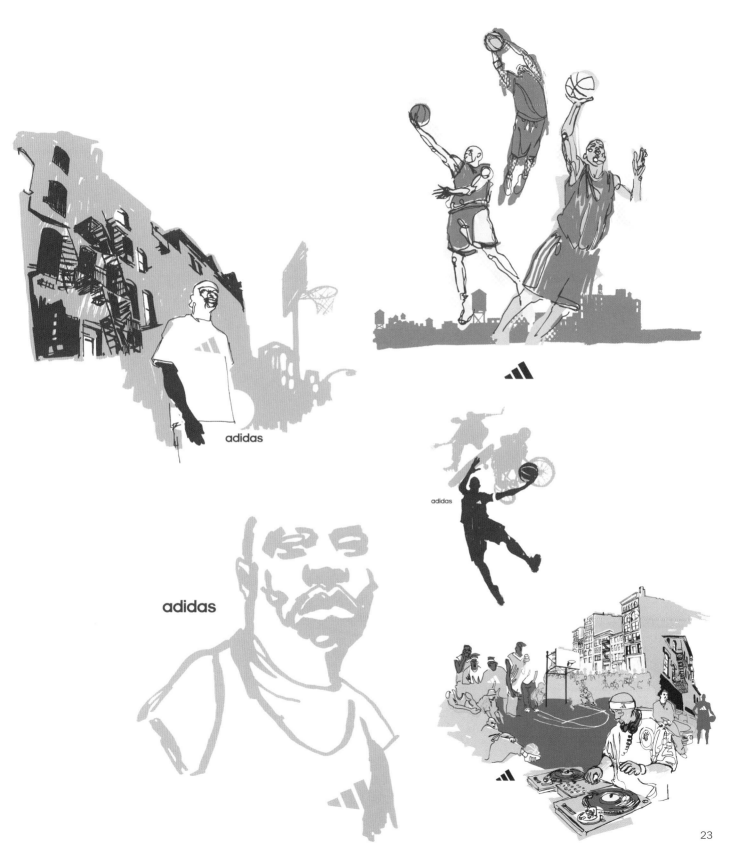

adidas

adidas

adidas

BINGHAM

Before you went to graduate school, you were responsible for a huge amount of imagery for underground hip-hop in New York City. At CalArts you became very critical of that work.

LYONS

Yeah, it called into question what exactly represents the culture in which I'm living. I was asked whether I was doing vernacular design or cultural design. I was, in fact, relating directly to the people who are part of this culture, but I began to question whether there was something higher that could be done? Can I take that a step further? Can I make this culture better, instead of simply responding to it, doing work they want me to do, as a member of this culture?

I don't think that I really affected the culture I was in then. I simply mirrored it. When I was designing for commercial people within hip-hop before I went to CalArts, I was motivated by making money and gaining popularity, by like, giving the people what they want. At CalArts, I was forced to question what it means to give people what they want. Is there something more rewarding both for me and for the culture itself, that I can do as a graphic designer? And I think I answered yes. What that is, I'm still struggling with.

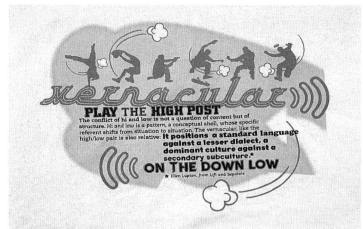

desTRoy
might blow up but won't go pop

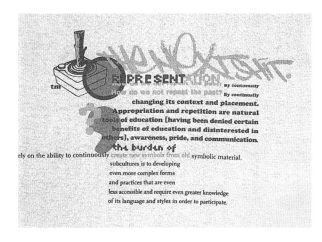

REPRESENT

How do we not repeat the past? By continually changing its context and placement. Appropriation and repetition are natural tools of education [having been denied certain benefits of education and disinterested in others], awareness, pride, and communication.

the burden of

rely on the ability to continuously create new symbols from old symbolic material. subcultures is to developing even more complex forms and practices that are even less accessible and require even greater knowledge of its language and styles in order to participate.

WHIRLWIND
and hits from every angle.

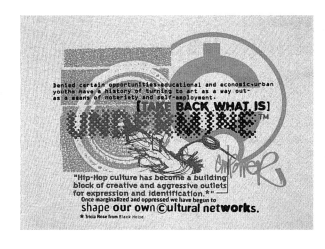

Denied certain opportunities-educational and economic-urban youths have a history of turning to art as a way out as a agent of notariety and self-employment.

[TAKE BACK WHAT IS]

"Hip-Hop culture has become a building block of creative and aggressive outlets for expression and identification.*" Once marginalized and oppressed we have begun to shape our own ©ultural networks.

★ Tricia Rose from Black Noise

MUCH RESPECT DUE

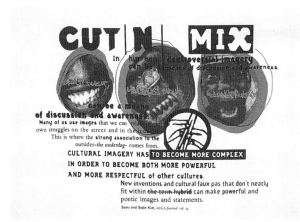

CUT N MIX

In hip hop controversial imagery can be a means of discussion and awareness.

Many of us use images that we can relate to in our own struggles on the street and in the industry. This is where the strong association to the outsider-the underdog- comes from.

CULTURAL IMAGERY HAS TO BECOME MORE COMPLEX IN ORDER TO BECOME BOTH MORE POWERFUL AND MORE RESPECTFUL of other cultures.

New inventions and cultural faux pas that don't neatly fit within the term hybrid can make powerful and poetic images and statements.

Somi and Sojin Kim, AIGA Journal, vol. 14

BINGHAM

During your first year at CalArts, Jeffrey Keedy referred to you as nothing more than a vernacular designer. I think he also said that they don't grant degrees to vernacular designers. So, how did you get out of that? When did you become more than a vernacular designer, and how?

LYONS

Well, he was right: I was a vernacular designer. Like I was just saying, I was totally within the culture, responding to the culture, and nothing more than that, not really adding that much to the world, as it were. I feel like in my first year I was faced with a strong backlash against my work.

BINGHAM

You seemed to always have to prove yourself.

LYONS

Yeah, and that was a real struggle for me. I disagree with the way that Mr. Keedy went at me, but at the same time, I have to be grateful to him. Even though it took him a year, he got me to the point where he wanted me to be when I graduated—definitely recognizing that I had a higher obligation both to myself and to the culture I claimed to represent. He helped me get to the point where I could step outside myself, be critical of what I was doing, and make my work better, and for that I can be thankful.

It's just the approach. I would have liked to have had that year back, so I could have worked this way for two years, rather than one. But I think no matter what, it was a very positive thing. You know, I don't regret anything about CalArts, and even if the world is a harder place for me to design in now because I'm constantly questioning what I'm doing I think it's a really positive place to be.

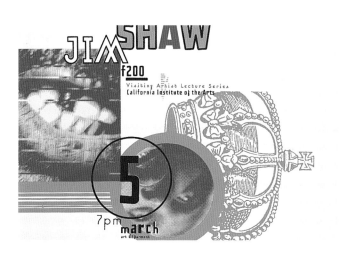

JIM SHAW
f200
Visiting Artist Lecture Series
California Institute of the Arts
5
7pm march
art department

tuesday, april
one
thomas ARR*

DOUGLAS
CRIMP

7pm LANGLEY

THURS NOV ONE H6 102

BINGHAM

Can you talk about your process?

LYONS

Everyone makes fun of my process. My process is to wait until the last second and then go crazy, go nuts. I am constantly working—I'm a bit of a workaholic—and so jobs run into each other and my work is inevitably rushed and extremely intuitive, even if it doesn't look that way, because I'm always doing it under rigid time constraints. My work is kind of off the-cuff. I'm throwing down and putting shit out there. I like doing the short, small projects, like the "POW POW POW," rather than working on long, drawn-out projects. So my process really dictates what I'm doing right now.

BINGHAM

Your original tools were markers, spray paint, and stickers. How does that translate into high-design processes and high-tech tools?

LYONS

Well, I don't really use any high-tech tools. I use a scanner and a G3 tower, but a lot of the stuff I do is still hand drawn. I scan it into the computer and use Freehand to make transparent layers and change color. The way I work is still very much related to layering stickers over drawings over spray paint. I still use a lot of spray paint. Instead of using digital effects in Photoshop, I kind of create them on paper and then scan them in and build them into a work.

When I was at Nike, my process actually got me into trouble, because people hated having to separate my work, it was so layered. They were like, "Why can't you just do this in Photoshop? Why couldn't you blur it and then half-tone it down and put it in?" But this low-tech approach is directly related to the style of my work.

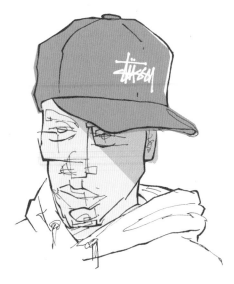

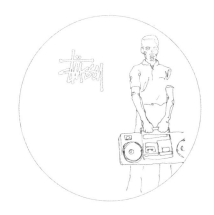

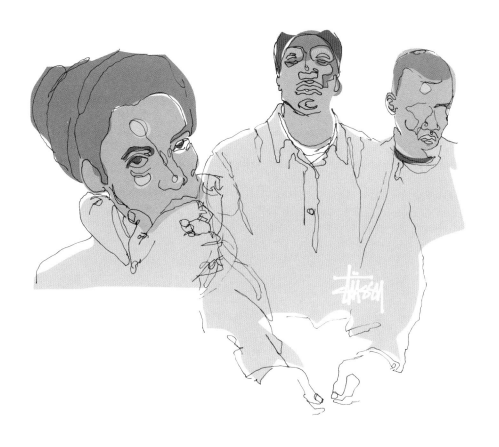

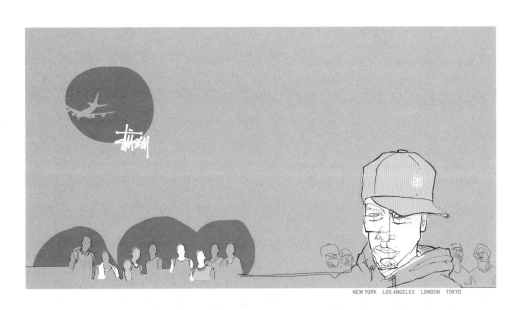

NEW YORK LOS ANGELES LONDON TOKYO

BINGHAM
Collaborations seem to be an important part of your process. Even at CalArts, you frequently collaborated with people. What did you gain from collaboration?

LYONS
One of the reasons I first collaborated with other graphic designers was because I didn't know how to get one of my designs to print. That's how I learned the computer. I learned from working with you, Geoff McFetridge, Beth Elliott, Michael Worthington. I saw how you all approached composition and used typefaces, things that I really hadn't thought about. I had one typeface—two typefaces, maybe—that I worked with before I was at CalArts, and by working with Michael Worthington I was exposed to working with many more. Collaboration really helped me educate myself.

I've always worked with partners. It comes from my undergrad background in film at R.I.S.D., where everything is in essence collaborative. You need a sound person, a camera person, a director, actors, and the influence of all those people brings out a totally different result than if you did it yourself.

Design for me is really kind of an experience of having a good time and banging out good work, and when I'm working with other people it's just much more fun than me sitting alone on the computer and channeling my own world.

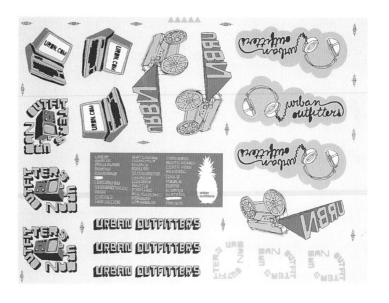

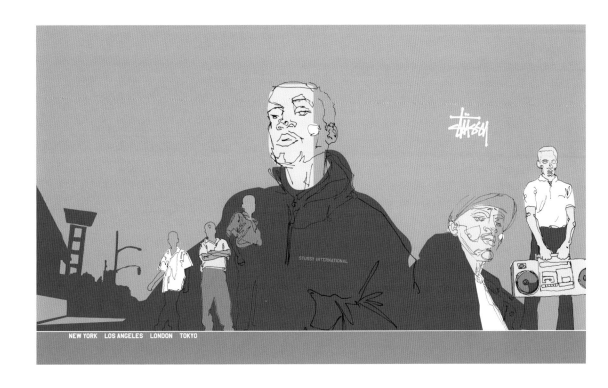

NEW YORK LOS ANGELES LONDON TOKYO

DREAM

SUCCESS BEGINS HERE

NIKE SWOOSH LEAGUE
EVOLUTION OF A PLAYER

PREVAIL

BRING YOUR GAME

EVOLUTION OF A PLAYER

BINGHAM

You arrived at CalArts with little technical skill and very little knowledge of Swiss Modernism and International Style design. Was that a problem?

LYONS

It was a huge problem. I had to learn it as I went along and bull-shit my way through it. But I think I was still an integral part of CalArts, and I think they knew what they were getting into. I mean, they picked me and maybe in some ways I didn't have that stuff, but they were hoping that I would bring a different approach to the department.

BINGHAM

Do you want to talk about you obsession with Barbara Glauber?

LYONS

I have no obsession with Barbara Glauber, only with the puffy clouds. I did have a weird sort of crush on Somi Kim . . .

In my thesis I used a lot of other people's styles or little inklings of what they did and in a humorous way I like to use appropriation now. I used your typeface. I used Barbara's puffy clouds. I used Michael's typeface. I made fun of Jens Gehlhaar's typeface. Glenn Nakasako, I made fun of Glenn. I made fun of Jeremy Dean. I made fun of all these different people . . .

BINGHAM

Want to explain the chain saw in the studio?

LYONS

I don't know where the chain saw is now. Beth tells me it's gone. It's been replaced by a G4 cube or something.

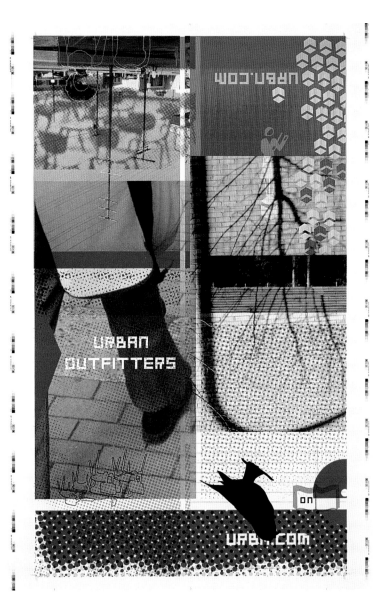

BINGHAM
And you and Geoff McFetridge had some turntables?

LYONS
Yeah. We had a DJ booth. But see, all that stuff was fun. All that stuff was like the fun stuff that Keedy didn't like us having. I think Ed Fella liked having the turntables in the studio, because he could listen to music while he worked. I think if you look back at his work at that time, it was seriously influenced by the music that Geoff McFetridge and I were playing. I think if you saw some of his projects of the time, there was a little bit of hip-hop in the Ed Fella style.

No, I think because things weren't always going great for me in design I was trying to have some fun. Maybe sometimes too much fun, but . . .

BINGHAM
How about Mr. Keedy and your confrontation with him over the graffiti markers, your first day at CalArts.

LYONS
I just have to say that Jeffrey Gra—I call him Jeffrey "Graffiti" because he has such a knowledge of the 80s and of the history of New York City graffiti. I mean, he was affectionately known at CalArts as Jeffrey "Graffiti" Keedy. He was simply looking out for me. He didn't want me to get caught, 'cause it was illegal and he put up when he was a kid and he knew. Going through the system in Valencia was not a good thing.

(Laughter)

No, I think Jeffrey Keedy didn't like me from the get-go, but he learned to love me.

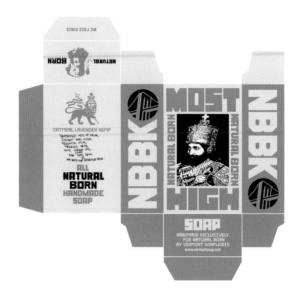

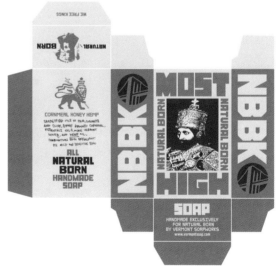

IT IS FOR YOU
TO WHOM I REACH FOR THE SKIES.
CITIES WILL NEVER FADE
STARWRITTEN ON UNDERGROUND TEMPLATES.
PRINCES AND THIEVES-
YOU BRING FORTH
A REVOLUTION OF SORTS-
I.E. OTHERNESS
WHICH HAS ECLIPSED
FULLY IMPLODED
FORBODE AND FORBIDDEN
CRUSH KILL DESTROY
BROTHERNESS.
MY BROTHER
MY TEACHER
SPIRITUAL PROVIDER
DIVIDER
ENEMY
PRINCE OF DARKNESS
FOR WHOM DO YOU REACH
AND CLAW
REACH OUT
FOR WHAT YOU READ ABOUT
BUT NEVER EVER SAW
YOUR WHOLE PERSONA IS...
STARWRITTEN-
BITTEN BY BITERS
THOSE OF WHOM
WHO REACH OUT
AND FLAT OUT TAKE
I HAVE TAKEN
I HAVE BUILT
BRICK BY BRICK
OF WHO I AM
AND WHAT I BE
SO IF YOU WANNA
RUN MY SHIT UP A FLAGPOLE
I WILL FLY
WHEN EMBRACED BY MEDIOCRITY.
LEGS WEARY OVER SWOLLEN STREETS
IN THE SUMMER HEAT.
ASPHALT ANGLES
FLIPPED SIDEWAYS IN RHYTHM
WITH STONE COVERED WALLS
WHICH BLOCK THE SKY
AND IMPRISON THE SUN.
TWILIGHT GOES BY WITHOUT NOTICE
IN A CITY SO GRAY.
THOSE GRIDS AND RIGHT ANGLES-
THIS SYSTEM OF SKELETON STRUCTURES
WHICH HOLD UP AN ENVIRONMENT
RIDDLED WITH QUESTIONS
OF MAKING MOVES.
WHICH PATH
THE SHORTEST DISTANCE
TIRED, YOU MAKE ROUTINES.
WATERTOWERS
BLOWN OUT GLASS FACTORIES
AND PUERTO RICAN RICE
BE YOUR GUIDES.

ENTER INTO EQUATIONS
AS THE ABRASIONS ARE SLOW TO HEAL
SIDEWALKS WHICH RUB YOU THE WRONG WAY
PEOPLE CHANGE THEIR ENTIRE SELVES
IN A MATTER OF WEEKS HOURS AND DAYS
AS WE ALL TRAVERSE THIS CITY-
THIS DEADLOCK OF GRIDLOCK-
SCOURING FOR SOMETHING TO LIFT US
ANKLE DEEP ALREADY.
PETTY CASH FOR A PETTY THIEF.
DISBELIEF IN DISMEMBERED OBJECTS-
DISEMBOWELED BEATS
RECORDED AND RERECORDED
DUPLICATED BEYOND REGONITION
THROUGH VARIOUS FOSSILS-
PHONIC DIGITAL REMAINS
DISCARDED USED NOW
TO HARNESS HOPE AND SOUND
THAT ECHOES OVER LINES DRAWN
COTTON HUNG TO DRY
IN THIS GOD AWFUL HEAT
PREYING DOWN ON EVERY LIVING SOUL.
SHOULDERS GROW WEAK
WITH THE CROSS YOU BARE.
FAKIN-
TRYIN TO BE MARTYRS
REACHING OUT TO SAVE OTHERS
AS WE PRETEND
TO BE DOWN.
FOR WHOM DO YOU REACH
WHEN IT ALL GOES DOWN
SCATTERED
SHATTERED
M.I.A.
NO WHERE TO TURN
AS THE FATE OF MEN
WITH MANY SOLO AGENDAS
BURN.
GASSED UP.
ASSED OUT.
DICKS IN THE AIR.
STAY YOUR GROUND.
TALE OF THE TAPE:
BROTHER'S GOT WEIGHT
BUT I GOT ALL THE

REACH

FOR WHOM DO YOU SERVE
AND BREECH MY COMMAND
TO SYSTEMATICALLY RESPOND
TO LEVELS UNKNOWN
UNFOUNDED AND DUMBFOUNDED
DOWNRIGHT CONFUSED
DEEPLY DISENCHANTED
REROUTED
MARGENALIZED
DISSATISFIED

PETRIFIED
CONFIDING IN DISTANT FACES
AND PERSONAS
HANDS OUTSTRETCHED
GROPING
AND REACHING
FOR SOMETHING TO HOLD ONTO-
A PLAN OR A MASTER
OR EVEN ANY COMBINATION
OF THE TWO
TRACKS LAID OUT
CURVED SEPARATELY
AND THEN MEET
AND SEPARATE AGAIN.
ABOVE HANG
LAID BRICK PUBLIC HOUSING
WHICH STAND TO KEEP US IN SHADOW
STRETCHED ACROSS TAR
WHICH GROWS SOFT AND RUBBERY
AS MERCURY RISES
AND DRIVES YOUNG MEN'S HANDS
AND FINGERS TO ITCH AND SCRATCH.
SO MUCH POTENTIAL BURIED UNDER OUR FEET
EMBEDDED AND CROSS THREADED
DETERMINING THE TAPESTRY
OF BOROUGHS
INTERWOVEN WITH FACES AND TRACES
OF WE SON-
VICTIMS
WHO REVEL IN RISING.
WHO TURN SUFFERING
INTO A RALLYING CALL
TO SSURVIVE AND SSURCH
FOR SELF.
WHEN KUNG FU GRIPPED:
RELEASE AND REACH OUT FURTHER
TO SAVE ONESELF FIRST
SO THAT YOU CAN COME BACK FOR OTHERS.
DO NOT UNDERESTIMATE
MY REACH
SON.

DO NOT UNDERESTIMATE
ME
SON.

FOR IT IS YOU
TO WHOM I REACH
FOR THE COOL CLEAR SKIES.

NATURAL BORN
212. 431. 5375

BINGHAM

Do you see yourself now as a designer working at the low end of "high culture," or at the high end of "low culture"?

LYONS

I'm doing what I'm doing, and sometimes it's interpreted as the low end of "high culture" and sometimes it's interpreted at the high end of "low culture." It used to be really important, how I saw myself. I liked to be seen as the high end of "low culture" because I thought it was more authentic. I felt like the low end of "high culture" meant that I was doing half-assed, high end work and wasn't really accepted by the high end. All those sort of complexities that go with the "high" and the "low" have fallen away for me, and I'm just sort of doing work. How it's interpreted and how it's classified by people doesn't matter as much to me now.

BINGHAM

Was this even an issue for you before CalArts, where every other conversation we had with Ed Fella was about "high" and "low," "high" and "low"?

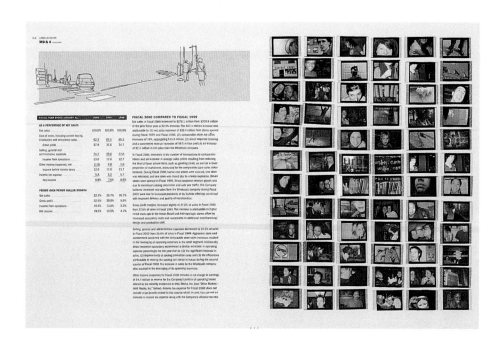

LETTER TO SHAREHOLDERS

URBAN OUTFITTERS INC. 1809 WALNUT STREET PHILADELPHIA, PA 19103

DEAR SHAREHOLDERS:

In early 1998, the Company unveiled a Five Year Plan designed to spur faster growth. The major components of this plan were simple: open new stores at a faster rate, make existing stores more productive by increasing sales and develop new concepts and channels of distribution such as catalog and e-commerce. Fiscal 1999 showed positive results as we began to implement the plan. We continued along the same path this past year, and once again the results were gratifying. In summary, total performance was the best in our Company's almost thirty-year history:

- Total sales rose 32% to $276 million
- Comparative store sales gained 30%
- Same core retail stores were opened during the year
- Direct response sales nearly tripled, increasing substantially
- Operating profits jumped 50% to $36 million
- Net income (after taxes and after adjusting for our strategic investment in MNG Media) increased by 39% to $19 million
- Earnings per share climbed to $1.05

DIVISIONAL HIGHLIGHTS

RETAIL OPERATIONS Urban Outfitters Retail, the oldest and largest of the Company's operating groups produced excellent full year results despite soft sales in the fourth quarter. Healthy productivity gains in existing stores, plus the opening of six new Urban stores, drove revenues up 19% versus the prior year. Selling square footage was increased by approximately 15% during the year (six new stores opened and one closed), meeting the aggressive "roll-out" goal which is a cornerstone of our Five Year Plan.

By all measures, Anthropologie Retail enjoyed an outstanding year. Fiscal revenues grew by 66% versus the prior year, and gross profit margins improved, as well. The group delivered consistent double-digit comparative store sales growth, and opened six stores during the year, bringing the total number of Anthropologie stores to twenty at fiscal year-end.

Anthropologie Direct, which operated for its first full year in early 2000, achieved sales of $15.2 million. At year-end, the mail order "house list" neared 200,000 names, and the number of visitors to the new anthropologie.com web site grew rapidly throughout the year, peaking in January 2000 with more than 185,000 unique visitors for the month. These achievements had a significant side benefit — a dramatic enhancement to the brand's awareness and development.

In anticipation of continued Anthropologie Direct growth and the launch of www.urbn.com, the Company brought call center and fulfillment operations "in-house" during the second half of Fiscal 2000. During this period of time, the call center answered more than 192,000 calls and the fulfillment center shipped more than 119,000 packages, all with a service standard favorably to the industry average and at a cost per order substantially below that of third party service providers.

WHOLESALE OPERATIONS Wholesale operations rebounded nicely in Fiscal 2000 after a difficult prior year. Revenues increased by 12%, and at the same time rose to excellent cost containment, profits nearly doubled. The number of active customers remained almost constant for the year, while sales per account increased. Wholesale inventory at year's end, January 31, 2000, was extremely current and was down substantially from the prior year. At the same time, Spring 2000 orders are running significantly ahead of Spring 1999.

INVESTMENTS, FINANCIAL CONDITION AND THE FUTURE

In the fiscal year just ended, the Company was required to "write off" all of its $4.35 million strategic investment in MNG Media, publisher of the MNG "magalog" and www.MNGonline.com. This "write off" decreased the Company's after tax profits by the full investment amount of $0.24 per share. Late in the year, MNG Media entered into an agreement with a second strategic investor, USA Networks. Even though the pricing of this additional financing would impute a significant increase in the value of our original investment, accounting rules mandated the "write off".

Given MNG Media's unwavering work with commerce-enabled entertainment and the continuing vibrancy in the company by outside investors, we remain confident in our MNG Media investment and expect positive results for our Company over the next five years.

In Fiscal 2000, besides the investment in MNG Media, the Company made significant capital investments in new stores and an expansion of the Company-owned distribution center. These investments, plus an aggressive stock repurchase plan in which the Company bought back 400,000 of its shares on the open market, combined to use more cash than was provided by operations. Despite this net use of cash, the Company's year-end financial condition was extremely strong. Shareholders' equity stood at a record $171 million, with over $32 million in cash and investments and no long-term debt. As the Company continues to make significant investments to execute its Five Year Plan, we expect to remain a net user of cash this year, as well.

Over the past three years, the rate of revenue growth has risen steadily from 11% in Fiscal 1998 to 32% in Fiscal 2000. During that same period, the rate of profitability growth has climbed from 5% to 39%. These results are ideal for the Five Year Plan, and are a testament to our employees' excellent plan execution. We intend to continue on the same path in Fiscal 2001 to:

- Opening a record number of new stores in the U.S.
- Expanding the number of Urban Retail stores in Europe
- Continuing to grow Anthropologie Retail by rolling out sixty percent more catalogs and reimagining the web site
- Launching www.urbn.com, the Urban Retail e-commerce site
- Continuing to grow the wholesale operation by adding more customers and increasing the average order size

Our goal, as often stated, is to deliver twenty to twenty-five percent annual growth in sales and profit. We are pleased to be back on track with these goals; we thank our employees, Board of Directors, and shareholders for getting us there; and we look forward to producing more record-breaking years in the future.

Richard A. Hayne
RICHARD A. HAYNE
CHAIRMAN

Glen T. Senk
GLEN T. SENK
PRESIDENT, URBAN OUTFITTERS

MARCH 31, 2000

CONTENTS ANNUAL REPORT 2000

The Annual Meeting of Shareholders will be held on Tuesday, May 23, 2000, at 10:30 am at the National Society of the Colonial Dames of America, 1630 Latimer Street, Philadelphia, Pennsylvania.

LYONS

It was not an issue. I didn't think about it when I was just designing "in the vernacular," as Jeffrey Keedy would say. I came into CalArts at a time when it was really being discussed and, yes, it was overly discussed at CalArts, and I did get sort of a complex, like, "Who am I, the low end of high culture or the high end of low culture? Which one do I want to be?" Then I sort of worked myself out of it and sort of made fun of it and used it to my advantage, and, you know, at this point, I'm pretty much resolved to the fact that I do what I do and I am doing what I love to do and that's the bottom line.

fresh dialogue 2000

WEDNESDAY, MAY 10
KATIE MURPHY AMPHITHEATRE
FIT BUILDING D
27TH ST+SEVENTH AVE

6:30 P.M. RECEPTION
7:00 P.M. PRESENTATION

// ONE9INE

one9ine

Interviewed by Andrea Codrington
Cal's Restaurant
53-55 West 21st Street
New York, New York
October 18, 2000
6:30 PM

CODRINGTON

So Matt, why don't you tell me about yourself. Where are you from? How did you end up where you are today?

OWENS

Well, I was born and raised in Texas. I started doing the computer stuff early on, when I was in high school, like flyers and record covers and things like that. Then I went to design school, at UT, Austin, where I met Dan Olsen, who went to Cranbrook. He encouraged me to go to grad school. Ninety-three was a really exciting year. Everybody and their mom wanted to be a cool, hipster designer, and going to Cranbrook seemed like this really cool thing. I got in right at the cresting of the wave, so to speak, right after Elliot Earls and those guys left.

CODRINGTON

Was Martin Venesky still there?

OWENS

Martin and Elliot interviewed me, so I was there with the last of the old school guys. At the end, in '95, people started questioning everything that used to be cool in '93 and '94. Half of us were like, "Why don't we just make all of our work this small and shoot 4 x 5s of it." There was this weird sense of, "What's the point if it's just going to wind up in a picture book." I guess getting into the Internet was sort of a reaction against that a little bit. A friend of mine and I started doing web stuff, and everybody thought we were stupid. I ended up moving to New York and working for a web development company for two years, and that's when I met Warren. Then in '97, right when Warren left to go to Cranbrook, I started doing my own stuff with Volumeone.

CODRINGTON
And that's when the Makelas took over?

CORBITT
Yeah, in '96. Matt was the last class of the McCoys, and I was the first class Makela actually selected.

OWENS
I'm old school, I'm like vintage.

CODRINGTON
You're cherry, baby, you're cherry!

(Laughter)

OWENS
I'm like from the web ghetto, but I feel like I'm much more a part of that era. All those guys were my Randy Rhodes when I was a kid, you know? I was like, "I want to be those guys." And I feel like as a studio and as individuals, Warren and I are very much a part of that lineage.

CORBITT
We're like, "Design as the discipline."

OWENS
That's our whole thing. We're a company that puts design first, and that's because we came from there and we believe in that. One thing about a lot of new media people, they have no ideological center. They have no belief system. Their belief system is the almighty dollar.

CODRINGTON
Well, they also don't have the kind of grounding in history that you received at Cranbrook.

OWENS
They're not reading Josef Müller-Brockmann.

CORBITT
They're like, "Who's Paul Rand?"

OWENS
Right. "Didn't he run some dot.com?"

CORBITT
I know. It's like, how ridiculous is that?

the**Codex**series[1]
narrative exploration beyond the book Josh Ulm. Tree Axis. Orangeflux. Volumeone.

the**Codex**series
1 narrative exploration beyond
Josh Ulm. Tree Axis. Orangeflux. Volumeone.

codex**two**
NARRATIVE EXPLORATION BEYOND THE BOOK

FRANCIS CHAN
SPENCER HIGGINS
ERIC ROUYERNECK

JOSHUA DAVIS
LEE MISENHEIMER
ANDY SISYPSEMA

PHILLIP DWYER
MATTHEW RICHMOND
FUMICHEI TAKEUSE

CODRINGTON
Warren, what's your background?

CORBITT
I grew up in rural South Carolina, in Hartsville, near Myrtle Beach, where there was no such thing as graphic design. No one knew what that was. So I ended up going to Vassar undergrad and majoring in Political Theory. I was actually designing my entire time there and doing a lot of political work with Act Up. I studied sexual-identity politics and wrote my thesis on Foucault, and when I got out of school in '93 I was like, "Okay, so now what do I do?" All these people told me, "If you don't have a design degree, you're pretty much fucked." I got an interview at Condé Nast through Vassar, and they eventually offered me a production job at *GQ*, which was a risk, because my HR person told me, "It's like church and state: If you're in production you're not going to move to design." But I still took the job, because I figured maybe there was a way. I became very close with Robert Priest, who at that point was creative director, and he basically took me under his wing as an apprentice. He would have me do the same layouts that his designers were doing, and we would just have these one-on-one crits.

CODRINGTON
That's incredible.

CORBITT
It was one of the biggest strokes of fortune I've had. I was also doing all of his production —kerning pull-quotes and learning about type from him. A position opened up for an assistant art director, and he moved me from production. I stayed in publishing until '97, when I went to Cranbrook.

46

there was once glass here, she swore to herself. she had seen the landscape. she knew now there is only sand, dusty and blinding. her eyes closed. the pearl tear hitting the

there was once glass here, she swore to herself. she had seen the landscape. she knew now there is only sand, dusty and blinding. her eyes closed. the pearl tear hitting the

CODRINGTON
Tell us a little bit about Cranbrook.

CORBITT
It was such a wonderful time. The Makelas
came in with all this fire and fervor. It was
like having the classic Cranbrook, but with
all the video and motion graphics and
performance. They were totally ready to
change the world. They had so much energy
and were totally committed. I did a lot of
installation work, a lot of video work,
projection work, and 3D work while I was
there.

CODRINGTON
So how did you two hook up?

CORBITT
I'd seen Matt's resume, and I was interested,
so I actually just sent him a blind e-mail and
said, "Yo. Like your work. Saw you went to
Cranbrook." Matt said, "Why don't you
come down for lunch tomorrow?" We went to
Kelly and Ping's, and we've been chatting
ever since.

(Laughter)

CODRINGTON
Chatting?

CORBITT
Chatting.

OWENS

Warren and I definitely come from different places, and we run our business in that middle space. I come from that sort of do-it-yourself punk-rock background, with that aspect of not waiting around for somebody to tell you to do it, but just doing it. My priorities come from the seedy world of web development, like the fucking horrible, get-under-the-hood-and-just-get-the-job-done stuff, you know? I know how to do all the crappy, crappy crap. Why? Because I had to, because there was no one else to do it, and I come to it with a level of pragmatism, because I've seen dreams dashed to the ground so many times in, like, the war-torn field of new media. I'm not the guy that's like, "Shoot for the stars, man. Let's go!" Warren serves that function.

CORBITT

I still haven't given up.

(Laughter)

CORBITT

I haven't.

OWENS

It's not like I've given up, but I'm definitely wary.

a bright | thin candy

am fm ★

DESTROY ROCKCITY

"get your shit together."
Destroy Rockcity

CODRINGTON

Matt, you're the pragmatist, and Warren, you're the optimist. Can you talk about some other polarities in your studio and in your work. What about commercial work versus personal work?

CORBITT

That is definitely one of them. Personal work isn't necessarily an excuse, as in, "I can't do this for a client, so I'm going to do it for myself." It's like an exercise, like doing chopsticks on the piano a million times. It keeps you constantly moving and thinking and reinventing, and it keeps you thinking through design.

There's this back and forth. In the work we did for Nike, Matt had just finished up a project with Volumeone where he had all these tiles that you could drag into a zone to trigger some narrative. We were approached by Weiden & Kennedy and Nike to do this interactive site that would continue the narrative of a TV commercial on line. We basically had to come up with a way for people to choose an ending. We sent them a link to Matt's thing on Volumeone and they were like, "This is pretty cool," and we sold them on it in the first meeting.

CODRINGTON

So does Volumeone serve as a test kitchen of sorts for these kinds of projects?

CORBITT

It's sort of like summer camp.

OWENS

Yeah, or like gym class. It's like you go to this place and you do this stuff to make yourself feel better, to keep fit. I do Volumeone because not a lot of client work allows you the space to like fuck around with an idea for two days and have it fail. It allows me that space.

THE AIR

SEAMLESS LINING. SO YOU CAN CONCENTRATE ON HITTING AND THROWING AND JUMPING AND RIDING AND EATING AND SINGING AND JUST ABOUT ANYTHING INSTEAD OF IRRITATED FEET.

THE AIR

SEE THE REAL SHOE NOW. ASK A SALESPERSON FOR HELP.

THE AIR

SEE THE REAL SHOE NOW. ASK A SALESPERSON FOR HELP.

THE AIR

SEE THE REAL SHOE NOW. ASK A SALESPERSON FOR HELP.

THE AIR

SEE THE REAL SHOE NOW. ASK A SALESPERSON FOR HELP.

THE AIR

SEE THE REAL SHOE NOW. ASK A SALESPERSON FOR HELP.

THE AIR

SEE THE REAL SHOE NOW. ASK A SALESPERSON FOR HELP.

THE AIR

SEE THE REAL SHOE NOW. ASK A SALESPERSON FOR HELP.

THE AIR

SEE THE REAL SHOE NOW. ASK A SALESPERSON FOR HELP.

CODRINGTON

I guess the difference between Volumeone and working out in the gym is that with Volumeone, you're working out in front of a gigantic audience. It's gotten a lot of attention.

OWENS

Yeah, the only reason it's gotten attention is because I try to do it consistently. I can attribute that to Elliot Earls. He told me a long time ago, "Just like Henry Miller, you have to have your program." You have to write every day. You have to work every day. Do I write a sentence about something, about an idea, every day? Yes, I do. Do I take a photo? Do I do a sketch? Yes, I do. Is it on the train? Is it at two in the morning? Is it between one thing or another? Yes. I keep that program inside of myself because I need it to stay alive. I needed it to stay sane. It makes me feel like I'm still thinking about things. That's what I miss about grad school. Running a business and doing a job well is one thing, but keeping your own brain alive and keeping your own heart alive and keeping your spirit alive creatively is a different thing. If I invested all of that into client work, for me personally, I would totally be let down. It's like a girlfriend. It's like, if you get your heart broken too many times, you know, you're going to be a little gun-shy. So that's kind of why I feel like I need this other space for myself.

issue no. six
spring.98
helpful lessons in color
the blinders
the maxims
sx - 70 picture gallery

summ
issue no. seven
summer.98
the tarmac
miracles of modern aviation
full.fathom.five
one goes there? yes.

volumeone
visual communication

an ongoing exploration in design authorship
presented in a quarterly format on the internet
www.volumeone.com

CODRINGTON

Do you have an outlet like that as well, Warren?

CORBITT

I'm not going to make excuses, but I'm only a year-and-a-half out of school, and I've done some personal work. I did a piece for the "Remedi Project," a seasonal site curated by Josh Ulm, and it was actually very hard for me.

OWENS

But you're a different . . .

CORBITT

I'm a different person, and also right now, for me, the business is so new. The rush is coming largely from running a company day-to-day. And I am the one, actually, who still gets my heart broken a lot, because I get hurt by clients when they don't agree with things that I really think are right for them. It's like clients will say that I'm acting kind of difficult, and I want to say to them, "You should be happy that I'm difficult. That means I actually care." If I didn't care I'd be like, "You want it this way? Sure. Actually, let me show you how to do it. Maybe it'll save you some money."

(Laughter)

OWENS

It's like a good tattoo. The best thing about a good tattoo is that there's unconditional trust. You walk in, you have an idea, you leave it loose, and you let the person do their job, because if they have a little investment in it, it's going to be way better than the shitty thing you like copied out of a magazine or thought up in your own head. That's the fundamental value—and beauty—of good design. It's that it's not just you and it's not just the client. It's that the client and you have trust in one another.

IMPLIED PROPORTION

CODRINGTON

So where does that trust come from?
Does it come from clients just kind of
getting you?

OWENS

It comes from meeting them. It also comes
by steps sometimes. Think about every
girlfriend or boyfriend you've ever had, and
think about how that romance evolves. That's
how a good client relationship is. Like,
sometimes you fall in love with them
immediately and they're like, "You suck!
You're horrible!" Or they're like, "I kind of
like you, but I don't really know," and then
you go out on a couple more dates and then
there's a trust and a bond. I mean, we have
clients that have become our best friends.
We have clients that become people that
we hire. It's amazing. It's amazing.

CORBITT

Right.

CODRINGTON

And how do you go about finding clients at
this point? Do people come to you?

CORBITT

Yeah.

OWENS

We just had a guy call us up saying, "You
guys want to spend $35,000 underwriting a
cable television show?" He's like, "We'll
give you six minutes of airtime." I was like,
"What are you talking about?" I think he
thought we were like some one-hundred-and-
fifty-person company. I was like, "Look,
dude, I don't want every sort of Wal-Mart
visiting, middle-class human being knowing
about what we do." You know, we have
enough stuff out there. We don't need a
PR machine.

ascendant

control

conde 2 onvey

sweet

one

Was it the time or the person
that made it feel that way?
That unexplainable aspect.

excursion://99
the season of autumn

VOLUMEONE
THE SEASONS INFORMATION

volumeone
THE SEASONS

COMPANY INFO

Codexseries

CORBITT

Plus, we're very small, and we're very small intentionally, so that if, say, the MOMA or Cooper Hewitt calls up and wants us to do their next two sites, and there's literally no budget for it . . .

OWENS

We can afford to do it. When we work with them it's an investment. We're not doing it just for the money. If we were twenty or thirty people, we wouldn't be able to afford to do that. That's the key. The bigger the company, the slower the decisions, the worse the work. Honestly, good things come from smart people working in a small group making smart decisions. The only way to do it is to make the decision-making process small and tidy.

CODRINGTON

Do your clients get what design is?

CORBITT

Well, when we hear what they're looking for and it sounds like something that's really more technical, or like implementing someone else's design idea, then we basically have to educate them. Sometimes they actually still think we're okay and they hire us and it works out.

MODERN *art* despite MODERN*ism*

INTRODUCTION

BACKWARD MARCH! IN THE AMERICAS

BACKWARD MARCH! IN EUROPE

POSTMODERNISM

MODERN *art* despite MODERN*ism*

BACKWARD MARCH! IN EUROPE
THE SCHOOL OF PARIS

Intro | Picasso | Matisse | Leger | Decadence | Balthus

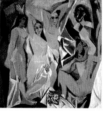

Pablo Picasso's *Les Demoiselles d'Avignon* shattered the mold of classical figuration and marked the arrival of Cubism in 1907. It was to take only six years before his early subtle courtship with neoclassical or baroque quotations (with illusionistic frames, carved musical instruments, wallpaper patterns and glassware as pretexts) became more pronounced when, in 1913, he combined a fragmented Cubist body with classical drapery in *Woman with Armchair*. His 1921 *Three Women at the Spring* is a painted assemblage of alternately rounded and flattened body parts locked in the stolid lifelessness that blunts its Cubist appearance. It is a tour de force of immobility willed into being at the cost of all that made *Les Demoiselles d'Avignon* a great and iconic painting.

Pablo Picasso. **Les Demoiselles d'Avignon.**
1907. Oil on canvas.
The Museum of Modern Art, New York.
Acquired through the Lillie P. Bliss Bequest

[o] [o] [o] [o] [o] [o] [o] BACKWARD MARCH! IN EUROPE POSTMODERNISM

INTRODUCTION BACKWARD MARCH! IN THE AMERICAS

REDUCTION

Designers in the modern movement emphasized function as both form and content of their furniture. "Modern" was not a style but a mission to respond rationally and directly to everyday needs at home and at work. Reduction—clear purpose, pure form, and absence of ornament—was a guiding principle of the modern movement.

Reduction design down to a statement of form and function. A search for the pure essence of things, minimally expressed, may arise from a philosophical or spiritual belief in the merits of simplicity. Innovations in materials and manufacturing technology—the introduction of tubular steel, plywood, and aluminum, for example—offer designers new opportunities to achieve more with less. Economic conditions such as a shortage of goods and materials in time of war or depression can also dictate a reductive approach to design. Regardless of its original mission, however, reduction has a pure aesthetic and a practical integrity that continue to appeal to designers.

THE GIRARD
MANIFESTO REDUCTION DECORATION ORGANIC DESIGN CONSTRUCTION TECHNOLOGY

MASTERPIECES FROM THE VITRA DESIGN MUSEUM
FURNISHING THE MODERN ERA

Cooper-Hewitt, National Design Museum is the only museum in the United States devoted exclusively to design and the ways it shapes and enhances everyday life. Accordingly, the National Design Museum is pleased to present *Masterpieces from the Vitra Design Museum: Furnishing the Modern Era.* Documenting and interpreting the history of industrial furniture design, this exhibition features highlights

MANIFESTO

REDUCTION

DECORATION

ORGANIC DESIGN

CONSTRUCTION

TECHNOLOGY

THIS EXHIBITION IS SPONSORED BY IKEA

the opulent eye *of* alexander girard

September 12, 2000–March 18, 2001

The first major retrospective of the designer who helped define 1960s style

Textiles as Foundation

House as Home

Display as Persuasion

Travel as Style

Folk Art as Inspiration

Alexander Girard introduced modern design to millions of people around the world. Girard's commercial and domestic interiors captivated the public with their theatricality. Synthesizing textiles, graphics, tableware, furniture, and fashion, he fused contemporary

This exhibition is sponsored by HAUTEDECOR

CODRINGTON

Do you create the content as well, or do you work with clients to create content?

CORBITT

Clients have come to us and said, "So you guys can just, like, write the copy for this thing?" It's like, no, that's what you have writers for. We can work with them on it, but we're not going to claim that ability or skill set.

OWENS

It goes back to design autonomy. Don't think you're God because you're a graphic designer. That's a bunch of crap. You have to know how to play with others.

CORBITT

And when to call others . . .

OWENS

And when to trust people. I trust programmers, I trust copywriters, I trust clients, because you don't have all the answers, you know? To do good client work takes a division of labor and a good grasp of semantics.

CODRINGTON

Is there an expectation that designers do provide these services?

CORBITT

I think it's a web thing. I think that people view websites as these all-inclusive entities that were birthed in a test tube. They hear we can do websites, therefore they think that we're are the keeper of the sacred temple. We've told clients that they have a lot of needs than we can offer at a very small studio. We're not going to promise something we can't deliver, because we'd just be defeating ourselves.

OWENS

Right.

CORBITT

So what's the point?

OWENS

Right.

style

COMPANY	Bless
DESIGNER	Desiree Heiss and

Ines Kaag

SCHOOL	University of Applied

Arts in Vienna and University of Arts and Design in Hanover, based
in Berlin.

CLOTHING FEATURED	White and black

eyebrow patch

KNOWN FOR	their limited edition

(quantities from 20 to 2000)
accessories and clothing which ranges from leather and jean
"boot socks," and fur wigs to bags and disposable T-shirts.

INFO	Ph +49 30 4434879.

Bless GbR, Kaag/Heis, Sonefelder Strosse 7, 10437
Berlin, Germany

"Our design is a never ending experiment with no fixed endings."

fall

09.1998

CORBITT

If we're honest with them that we really focus on design—and design as a way of thinking, of actually processing ideas and thinking about user experience—then we're all going to end up being much happier and, ultimately, with a better product.

OWENS

And we also do the traditional design stuff.

CORBITT

We're not just on line.

OWENS

What clients want is not necessarily a print problem, or a broadcast problem, or a new media problem. We met with a client yesterday about a potential project that has a broadcast component, a print component, an on line component, and then maybe a takeaway, pseudo-interactive component, like a CD-ROM business card or something. I mean, there used to be a day when you could be a card carrying member of the graphic design community and bust out some stuff in Quark and go to bed happy, and like, I'm sorry, but that day is over. That day is long gone.

CORBITT

Because an identity is going to play out in print, on line, in broadcast. When we're doing identities now we're not only thinking about them in terms of how a design will look on a business card, but how it'll look animated on a website, how it can be incorporated into a TV commercial.

OWENS

I think that traditional print design is just one part of the whole picture.

CORBITT

Sometimes the media itself suggests content. I remember at Swoon, I was meeting with the editors and they had this story about a couple moving in together and how it changed their lives. The editors were asking how we could present it on line, and I was like, "Basically, what you guys are talking about is how each room has changed by the couple moving in together, so why don't we structure the story like a living room, a bedroom, a kitchen. . . ." So the interface was actually able to drive the story. You hear about designers that are content makers because they always make things mean, but we're actually now being recognized for that potential, and that's a fundamental change. We're no longer seen as the people who just make things look pretty.

OWENS

I think that it's negotiating in a space between the old school notion of a designer as making something look pretty and the notion that media designers are the facilitators of needs. You have to chart a course around those two big roadblock: "Here's the stuff. Now go do your pretty magic," which is total bullshit, and the flip-side, which is, "Oh, you guys are those crazy computer dudes. Why don't you do your computer magic." It's like, "Fuck you and your 'computer magic.' Fuck you and your 'make it pretty.' Let's get some ideas grounded, and let's use both our technical and aesthetic expertise to make sense of this thing and make it meaningful and make it real."

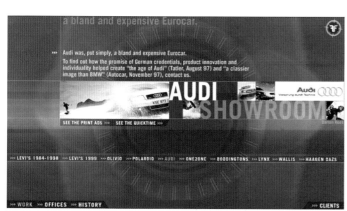

a bland and expensive Eurocar.

>>> Audi was, put simply, a bland and expensive Eurocar.

To find out how the promise of German credentials, product innovation and individuality helped create "the age of Audi" (Tatler, August 97) and "a classier image than BMW" (Autocar, November 97), contact us.

AUDI SHOWROOM

SEE THE PRINT ADS >>> SEE THE QUICKTIME >>>

>>> LEVI'S 1984-1998 >>> LEVI'S 1999 >>> OLIVIO >>> POLAROID >>> AUDI >>> ONE2ONE >>> BODDINGTONS >>> LYNX >>> WALLIS >>> HAAGEN DAZS

>>> WORK >>> OFFICES >>> HISTORY >>> CLIENTS

The R&D department at the Fame Factory is where we explore advanced methods of creating fame and fortune for our clients.

John Bartle - Joint Chief Executive

REACTOR CORE

The message has been manufactured. It's sitting in pallets on the loading dock.

UNLIMITED DISTRIBUTION

LONDON

CODRINGTON

It seems like we've also entered a time when form and content are approaching each other. They are closer than they have ever been and are sometimes inextricably bound together. You guys pay tremendous attention to form, and although I wouldn't call you formalists necessarily, there's a kind of baroque attention to surface in your work.

CORBITT

Sure, I mean, it's luscious, in comparison to this kind of new minimalism thing that's happening right now.

CODRINGTON

Is this an intentional thing? Is it in rebellion to this kind of flattening of the surface everywhere?

OWENS

I think our work is pretty minimal given what's come before. Given the aesthetic approach of, say, Super Ravy work or the Attik, I think our stuff is pretty pulled back. I wouldn't say its totally crazy.

CODRINGTON

There's a busted-out, sleazy element to your work.

CORBITT

Yeah, but that's really more about being human. We've been talking about this whole idea of bringing emotion and feeling and humanness to this technology. Ultimately both Matt and I really want to feel the work that we're doing. I don't think it's so much a need to be excessive or decorative, but just to have an opinion to put a stake in the ground and say, "This is what we believe. This is what we're feeling." We want you to see this and get something from it, to feel it, to have a conversation with it, for me, that's what distinguishes us from the new minimalism, which often can be very plain to the point of like absence. It's like total Sartre.

5

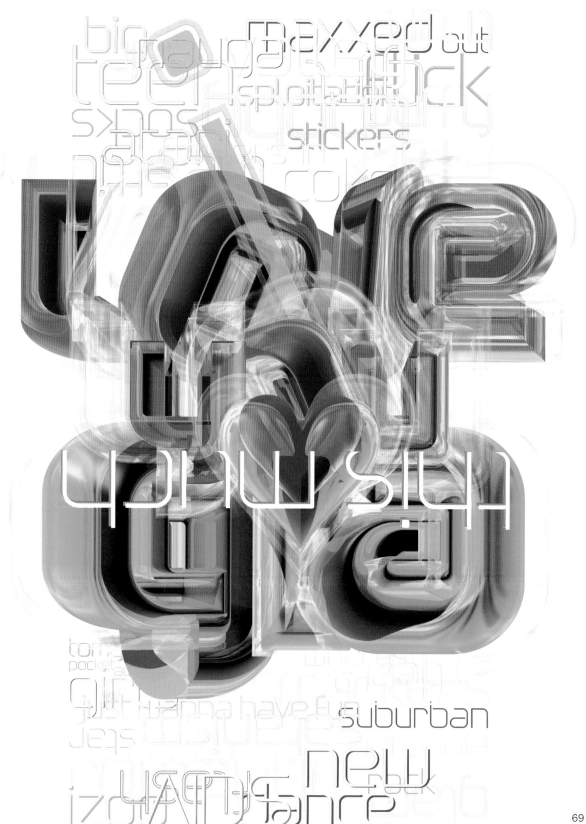

maxxed out

big

splashback

stickers

this much

suburban

new

dance

69

OWENS

It's like you look down and you just feel
rather empty. But I think that Josef Müller-
Brockmann and Jan Tschichold did it in such
a way that it totally blows me away. When
done well, it's amazing. I definitely think
that some of our work is influenced by it,
but we definitely have our own take on it.

CODRINGTON

Is there ever a concern that one9ine is going
to be considered a style shop?

OWENS

No. We don't run it like a style shop, so I
don't think we will be considered one.

CORBITT

We never get the question, "Can you make
it look like that?" or, more importantly, "Can
you just make sure that it doesn't look like
that, because that's what our competitor
looks like."

OWENS

We're occupying a weird space as a design
firm. It's like, we're not Stefan Sagmeister
or Designers' Republic, but we list in that
direction. We're not Kioken or 52 Millimeter,
but we list in that direction. We're definitely
in the middle and with very good reason,
because there are limitations to both
approaches. Between the design critique of
the Designers' Republic and the new media
golden children of Kioken, there's a space
that you need to inhabit to be smart and to
not be a style shop, or a "service functional"
shop, or whatever.

CORBITT

There's a lot of room to live in there.

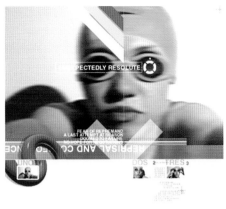

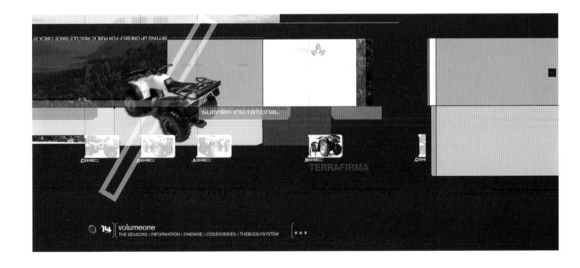

CODRINGTON

It seems like there's this siege mentality with a lot of designers who aren't involved in multiple media the way you guys are, and I wonder if there's something about this that's making people put out huge monographs about themselves. You know, it's like the age of the big designer book. Bruce Mau is coming out with one. Stefan Sagmeister is coming out with one. Tibor Kalman has one.

OWENS

I think an era is over, to some extent.

CORBITT

I'm wondering if the monographing isn't almost more of a regressive act; if, because some designers are not in a position, for whatever reason, to put a portfolio or self-promotion on line, they are take another route. There is definitely a self-promo thing happened through the net. It wasn't intended to actually be this way, but people are definitely making names for themselves on line.

OWENS

You can definitely see the value of the generation or two that came before us and how what's happening now is all malformed and confused. Branding is coming into question. What is new media? What is print? What is motion graphics? How do they interrelate? We're trying to identify some milestones and bring to the table a sense of what's going on. Then, once the technological and conceptual issues are hammered out, it's a whole new generation. That's really exciting.

sink or

Complex equat

CODRINGTON

It seems that in the past five years, the barriers between design disciplines have crumbled. That's been a tremendous thing for some designers and a horrifying thing for others. Where do you draw the line between, say, art and design?

CORBITT

No comment.

OWENS

Too complicated.

CODRINGTON

You don't want to touch it?

OWENS

I don't know. I think art is a whole animal in and of itself.

CODRINGTON

So Volumeone is not art?

OWENS

It is what it is, you know?

CORBITT

I see this conversation as a waste of space when we all could be making something. If you're making something that you believe in and that you want to show either to yourself or to an audience—and that's often the distinction between art and design—I don't think it matters

OWENS

Some people think Chris Ware makes comic books.

CORBITT

Some people think he's a designer.

OWENS

And all I know is he makes awesome shit that I believe in.

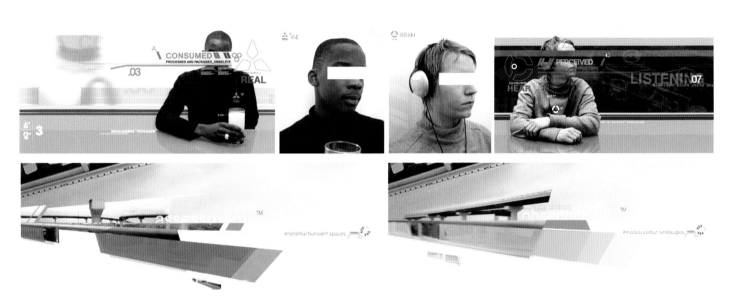

CORBITT

We just saw the Ray Johnson exhibit. Is he a designer? Is his work typography?

OWENS

Is it collage? Is it painting? I don't know.

CORBITT

So what is gained by sticking him in a category?

OWENS

I've seen tons of design work in museums and in galleries. Does that make it art? What definition do you apply to it? I don't think it's necessarily that important anymore.

CORBITT

Or relevant.

CODRINGTON

Your work has been described by some as "digital machismo." There is something very athletic and very masculine about it.

OWENS

It's very sensual, as opposed to masculine. There's a certain level of sexuality to the work in general.

CORBITT

I think the only time gender enters into our work is in terms of polarity, the idea of penetrator and penetrated, phallus and orifice; that kind of tension between the receptor and the device, things locking up and making connections. I don't know if I necessarily think about it as much as I recognize it. I think that often people respond on a primal level to making connections, and it doesn't have to be sexual.

OWENS

In generating 3D forms—cybergraphic forms especially—that definitely comes into play. I think it takes place on a subconscious level when you're dealing with interior and exterior form. There's a certain level of sexuality that just comes with the territory and you have to be willing to embrace it.

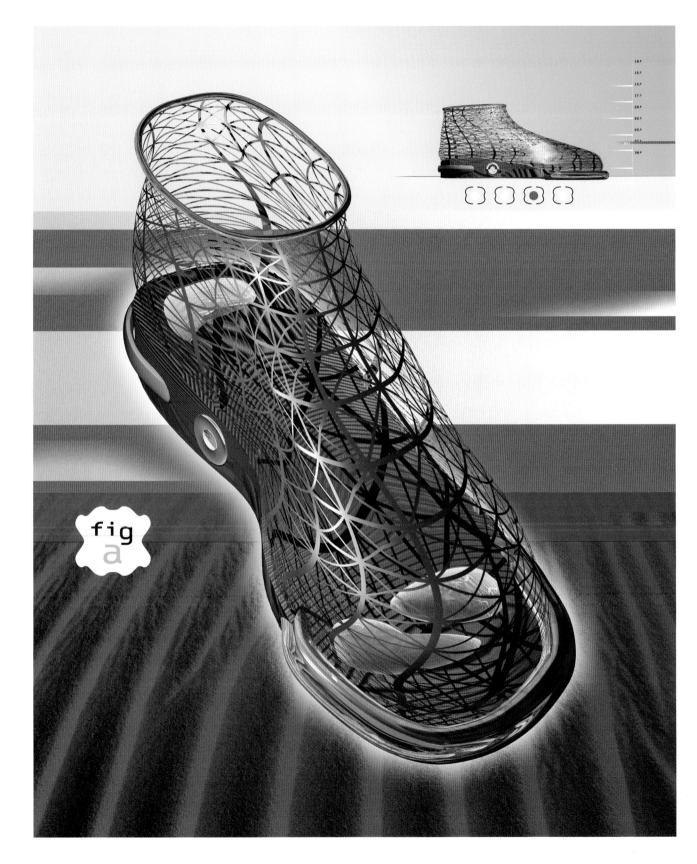

fig
a

CORBITT

I'd rather have that, quite frankly, than the cold, mechanical nature of so much 3D work that's happening out there.

OWENS

Completely. Definitely.

CORBITT

And I think that because it's so not cold, that when it comes anywhere near human flesh touchable, that we immediately attach sex to it.

OWENS

If you're making those associations, that's great, as opposed to the alienating, like . . .

CORBITT

"Look how well they rendered that object. You're such a good 3D artist."

CODRINGTON

There's something fleshy and meaty about your work that sure puts my mind on "Sex Alert."

OWENS

But I think that's more like the juiciness of it. It's juicy and seductive and engaging. We actively think, "Okay, now that it's done, how do we add another level of nuance? Invest it with that other layer of stuff that sucks people in."

CODRINGTON

What would be the ideal one9ine project?

OWENS

I think the best thing would be to find somebody who was able to go the distance with us—conceptually, creatively, from a media perspective and from an execution perspective. It's like, "Okay, let's take it to the next level. Let's push it a little further. Let's go." Because I think I can do more than they're going to let me do. If you find us a client that's going to let us go the distance and really do what we can do, we can do amazing stuff—between media, aesthetically, conceptually, technically. That's what I want.

CORBITT

One of the main problems that I have with this whole new media industry is the time frame. We get an RFP that says, "We will design on a contract starting November 15th. We need the website done December 18th." How exactly can one produce a good product in that amount of time?

OWENS

Right now people want it tomorrow. Time is a limiter. I think that being able to produce something really amazing requires thought and it requires passion, and that requires time.

CORBITT

It's like, we tell the client we want more time, and they're like, "Well, we don't have it." Then we're like, "Okay, then this is what we can do," and they're like, "Well, just make it as good as that can be," and we're like, "Okay." It's all we can do as professionals.

OWENS

I feel like we're the kind of studio that wants to push a client as far as they'll let us. It's like, don't just come to us to do a job. Let's do something more—something better—than a job, you know? I mean, that's the dream. What you want is every day to be like grad school.

CORBITT

You want every job to be like the best dinner party you've ever been to.

OWENS

Yeah, yeah, yeah. It's like, we do this studio out of love, because this is what we need to do, because this is what makes us happy, and you want the clients and the projects that allow you to have that love. I mean, if I can't feel it, fuck it. You know what I'm saying though? It's like, I think everyone who's young and comes to design wants to feel like they have that place. We're still . . . we're still fighters, you know?

WHICH WAS NEVER RETURNED

Leather

collar

WHEN WE FELT THE COLD SKY

WHEN YOU BORROWED MY JACKET

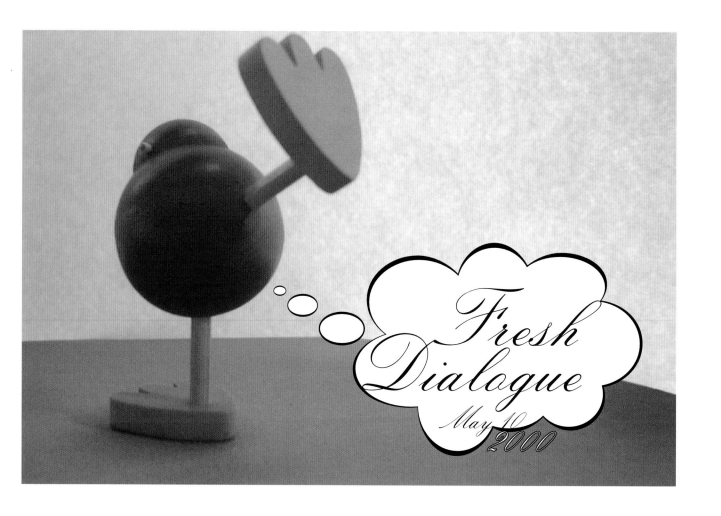

ReVerb

Interviewed by Brett Wickens
ReVerb offices
5514 Wilshire Boulevard
Los Angeles, California
November 3, 2000
11:00 AM

WICKENS

I was hoping we could begin by talking a
little bit about how ReVerb was formed.

KIM

Lisa and I met at the California Institute of
the Arts while receiving our MFAs. We
formed a design collective in 1990 with
Susan, who had studied design at Parsons
School of Design in New York, and with
Whitney Lowe and Lorraine Wild. At first we
just shared space and equipment, but we
soon realized that we had a common love for
experimenting with form and an interest in
the editorial function of design. Pooling our
abilities made us a stronger team, capable
of taking on larger projects. We founded
ReVerb in 1991. In the mid-90s, Whitney
and Lorraine left to pursue different career
paths, and the three of us have continued
on as ReVerb.

PARR

Our first studio space was an 18- by 25-foot
room in this building, Desmonds Tower. We're
still here, but now we occupy two floors. The
space is raw and open, and I think the studio
itself has had a real physical impact on our
collaborative approach, since it allows for
constant social interaction.

NUGENT

We also shared an interest in developing a
new business model. Historically, most
design studios were built around a single,
star personality with a trademark visual
approach—a hierarchy from the top down.
We wanted a horizontal structure, where
ideas could flow democratically.

WICKENS

In your opinion, does design add value or does it create value?

KIM

I think it depends on how you define "design." We share an expanded definition of what design is. Design is not only about the formal qualities of visual communication. It's also about the relationship we have with a client, and about their relationship to an audience, and about what's happening in the world. Understanding design in this broad sense can create value. Things don't happen in isolation. It's all about the contexts, which are constantly changing.

WICKENS

So process is part of design?

PARR

Often clients come to us because they want the "ReVerb treatment." This usually means that before any formal execution takes place we take a close look at them and then show them what we see—what the consumer actually sees. We present this information in the form of maps or charts that communicate the big picture quickly and frame the problem or task at hand, whether it's creating a product line or launching a business. Like in the case of MTV, we visualized one month of viewing on a single page.

MTV seen through the eyes of **Katy**

MTV = RAP MUSIC AND POSER VJs (IDALIS CLONES, CARMEN ELECTRA, ETC.) WHO THINK THEY'RE COOL (EXCEPTION: KENNEDY, DUFF, KURT LODER)

GOOD MUSIC TELEVISION = MORE VARIETY!!!

Katy Jones, 13
born/lives in Beverly Hills

TODAY: singer / performer / student
TOMORROW: "singing up on Broadway"

PERSONAL PLAYLIST: goth — Marilyn Manson, NIN (Trent Reznor); punk — Dead Kennedys, Black Flag, Misfits; David Bowie, Tori Amos, Hole, Pink Floyd, Nirvana

TV/CABLE PICKS: cartoons on Cartoon Network, the news on Fox 11. Anything on VH1 (except the Beegees or rap)

6 FAVORITE THINGS: (1) my guitar (2) my CDs/tapes (3) my cat (4) Reeses Peanut Butter Cups (5) all my pictures of Manson/Trent!!!! (6) "The Tell-Tale Heart"

OPENING VIBE:

ESTABLISH BEAT:

NUGENT

Clients frequently approach us with a very ambiguous question and ask us to formulate a plan for how to answer it. By talking with them and among ourselves we hone in on the central issues. Sometimes we say, "Well, maybe that's not the right question. Maybe it's this other question that should be asked, or asked in tandem."

KIM

For example, Hewlett-Packard asked us, "What is the nerd or geek in popular culture today?" They knew they were considered the "beige-box" company of engineers—the quintessential nerd among technology companies. We created a discussion document that touched on different things, such as consumer comfort level with technology. Then we did a one-on-one interview with a serious tech-head, and that led to more interviews and to a real interest on our part in integrating research into our design process. It didn't start there, but this was one project that wasn't about delivering a design solution; it was about exploring an open question. This was our first pure research project independent of visual execution.

PEDIATRIC HEMATOLOGIST Orange County, CA

Diane 50

One thing technology can't replace, though, is that important human element—what we call the doctor-patient relationship. There's a human element to getting bad news about our medical condition. . . Part of the problem with technology is that we [primary-care physicians] are always and instantly accessible. How do we manage all the information that's coming in?

In my research work I collaborate—as does my husband—with people around the world on clinical trials or data, so email is an important part of the communication. I've been accessing online medical information and databases that relate to patient disease for diagnostic purposes for at least 10 years. And how many patients do their own research about medical conditions on the Internet, which in some cases makes the doctor-patient relationship a more collaborative one. Data collection, processing and recording has become much, much easier with the computer. I can access lab results, radiology results and so on.

We've never been at a time when there is more available technology, but these things cost money. The technology has far outstripped our ability to pay for it in most cases—and yet it is here.

"Technology has radically changed the way I do medicine. I'm a much better diagnostician because of it."

Heard on the street: nerd/geek popular icons

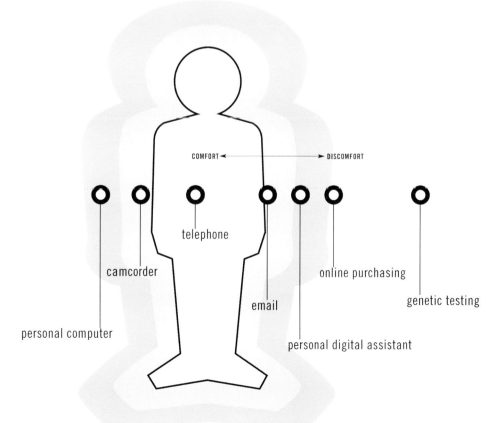

WICKENS

Having followed ReVerb for a number of years, I've seen shifts in the nature of your work, especially through the introduction of this research component, which builds audience understanding in a less quantitative, more experiential way. Was there a definable point when that became important, or did it just evolve over time?

NUGENT

The shift happened when we started the studio and found ways to build on each other's ideas. We started to conceive our own projects and build content through research. The Blood Project is a good example. It was inspired almost six years ago by the deep emotional response that blood triggers in our culture and by the shortage of blood in our national blood banks. When we were kids, becoming blood brothers or sisters with your best friend by cutting fingers and mixing the blood together was an accepted ritual. Now, with the awareness of HIV, any contact with human blood is feared. We started conceptualizing a project that would take a mix of superstitions and cultural myths about blood and juxtapose them with current scientific knowledge. In researching the project, we uncovered fascinating anecdotes about blood that brought to light its relationship to personal identity.

WICKENS

Are there parallels between this project and more recent work in terms of understanding how different audiences have different perceptions about things?

PARR

I think so. In some of our early work, the way we went about our research led us to create multiple viewpoints, and now, working with large corporations, we still engage in those same exercises. The questions have just gotten bigger.

DONATION

Blood donation and the official regulation of blood donation has in recent times been galvanized by individual and collective need

May 30, 1980
[text] Korean American student activists march through Los Angeles's Koreatown to protest the Korean government's brutal crackdown on a student uprising in Kwanju, Korea, which killed over 250 people. A group of these students initiate a blood drive at a local Red Cross facility, collecting over 90 pints of blood. They demand that this blood be sent directly to Korea to aid the students injured in the uprising. The American Red Cross refuses to send the blood unless it is specifically requested by the Korean Red Cross

December–January 1991
While American troops are engaged in the Gulf War, the Pentagon calls for the tripling of civilian blood donations. They ask the American Red Cross and the American Association of Blood Banks to each ship 375 pints of blood a week to the gulf region. Two weeks later, they request that the amount be increased to 1000 pints per week. [LOS ANGELES TIMES 1991]

June 1997
Dr. Betty Shabazz, the widow of Malcolm X, is severely burned in a fire in her apartment building. The Amsterdam News and Carver Federal Savings Bank organize a blood drive on her behalf. On the first day, 400 donors participate, contributing 265 pints of blood. One donor wrote a note to the Shabazz family: "I gave blood to you because of the blood your husband lost when he was alive. I don't know you, but I love you." Shabazz eventually succumbed to her injuries, but the blood collected (700 individuals eventually donated) was dispersed throughout New York, providing a much needed resource that is usually low during the summer months. [AMSTERDAM]

January 1996
Ethiopian Jews protest at the office of Israeli Prime Minister Shimon Peres when the media reveals that for years the country has discarded the blood donations of Ethiopians. In protest by asserting that Ethiopian immigrants are 50 times more likely to be infected with AIDS. One protester held a sign that read "We are black, but our blood is red."

1 need

Blood of My Blood

The people of the Mezzogiorno survived a harsh history of invasions, conquests, colonizations, and foreign rule by a procession of tribes and nations. What enabled the Contadini to endure and develop their own culture was a system of rules based solely on a phrase I heard uttered many times by my grandparents and their contemporaries in Brooklyn's Little Italy: sangu du me sangu, Sicilian dialect for "blood of my blood." My grandmother's favorite and most earnest term of endearment when addressing her children and grandchildren, and when speaking of them to others, was sangu miu—literally "my blood." [RICHARD GAMBINO, BLOOD OF MY]

More than 10 million units of blood are transfused annually in the U.S.

You have been injured in a car accident and your survival depends on receiving an emergency blood transfusion. Suddenly you realize how the intersection of **Body / Culture / Science & Technology** that constitutes your individual point of view affects your comfort level as a beneficiary of a group of anonymous blood donors. Whose blood will soon be sustaining you, running through your veins?

Unknown to You

relationship to patient
gender
age
medical history
social history
occupation
dietary practice (vegetarian/meat-eater)
ethnicity
religious affiliation
political affiliation

WICKENS

Do you find that corporate clients are open to understanding their audiences by doing this kind of research, or do you have to argue its value over more typical corporate analysis, where you take a bunch of statistical information and mine it for patterns or demographics?

PARR

We don't need to argue its value, since clients come to us looking for something different, something other than statistical information. They're looking for findings that are on more of an emotional level. They're looking for a connection with their audience, for messages that ring true because they are authentic.

KIM

Clients aren't coming to us to replace the traditional ways of doing research. It's not about getting statistically significant results, but about taking core samples to find out what's relevant to their consumers.

Our approach takes different forms. There's the secondary research, which includes marketing message surveys, industry scans, visual research, and internal company audits. Then there's the primary research—the fieldwork, or ethnographic research—which involves street-level audits, one-on-one interviews, site visits, and visual documentation in the form of photography and video. All of the data is analyzed and used to determine brand positioning or targeting recommendations or a communications strategy.

www.den.net

net television for us

>en.

www.den.net

net television for you

>en.

WICKENS

Does this kind of research enable you to uncover interesting information about audiences that might not be uncovered in other ways?

KIM

Yeah. Different things and scary things.

(Laughter)

KIM

One thing that we've found is that people describe themselves one way, but then demonstrate very different behaviors. They'll say, "Well, I'm not really into technology at all," but then, when they describe what they do or we observe them, we find that they're actually using technology in all aspects of their lives.

WICKENS

What they say and what they do are two different things?

KIM

Yes, and that gap is interesting, because it points out communication opportunities.

WICKENS

Let's talk some more about "branding," because that word has as many meanings as the number of people you ask to define it. How do you define branding, and do you think that it has changed over time?

PARR

You mean it's not just a logo? (Laughter) You develop a logo and then you put it on everything. (Laughter) A brand is more than just a logo. It's about an experience, or a group of elements and influences that build an experience. Because the logo is seen as a tangible visual asset, some clients focus on it as the starting point. We occasionally engage in conversations with clients about just how much a logo can say, verses how much is communicated by the other elements that create the "look, feel and voice" of the brand.

KIM

When we talk about "look and feel," the "feel" can encompass nonvisual nuances of experience and expression, including tone of language, interaction, and sound.

NUGENT

I think more CEOs are becoming aware of the value of a brand as a business strategy, and when they support a brand's expression throughout the corporation it becomes more feasible to do good work. When the logo is considered a stand-alone design component, its potential is lost. I think that unless there's support from the top, it's almost impossible for a company to truly live up to its brand promise. It represents a huge effort and a long-term commitment on the part of many different groups: marketing, merchandising, advertising, etc.

WICKENS
Do you ever speak with clients about the broader brand landscape, about parts of the landscape that fall well outside the obvious visual articulations of branding—like behaviors, how someone answers the phone, that kind of thing?

PARR
In terms of creating a total brand landscape, we plan out experiences and create scenarios in the form of a framework. A framework identifies all the elements of a brand experience and prototypes key examples so that we can quickly show how a brand would play out across different media, from answering the phone to product packaging, tradeshow booths, architecture and interiors, advertising, management style, and public relations. In one project, we renamed the conference rooms to create a new employee vocabulary that was more light-hearted.

WICKENS
To what extent do you use modeling to identify how a company's audience might interact with the brand?

PARR
We build experience scenarios to imagine how brand elements and communications would play out. We build audience profiles as a way of assessing how brand elements could reach specific audiences.

NUGENT
It depends on the client's needs. We're developing a framework for a new brand position for Sony VAIO. We're in discussions with them now about what's going to be the most useful, because to truly flesh out all the different consumer points of experience would be . . .

WICKENS
Huge?

PARR

Huge. When the scale of a project prohibits us from taking it that far, we need to be adept at planning the experience.

NUGENT

With large corporations, repositioning a product also has great internal impact. There's a need for internal consensus building. Starting with the research phase, we deliver milestone reports to the company, so that information can be discussed and input gathered from everyone with a stake in the project. The framework and prototyping enable the client to determine if the new positioning rings true by seeing the product's brand world take shape. It shows them what that world is going to look and sound like. At this point they can hold it up to the light and see if there are any flaws in it. The framework then becomes the basis for creative briefs and modeling situations.

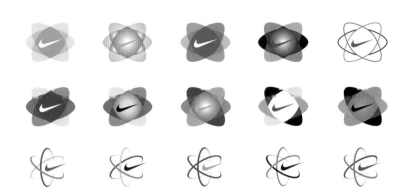

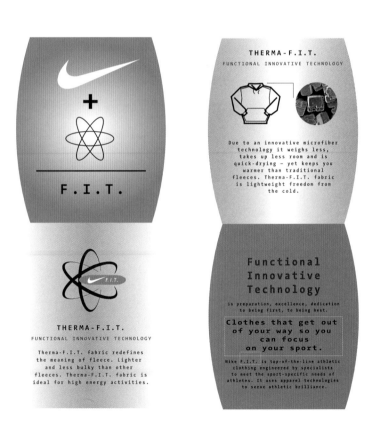

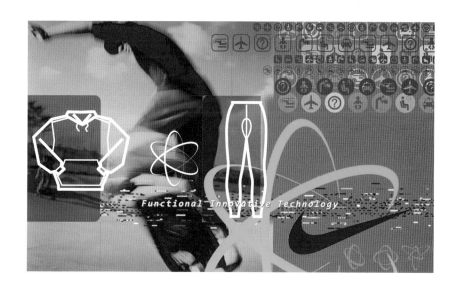

Functional Innovative Technology

SPORTS + INNOVATION +

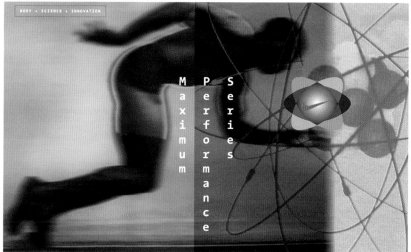

BODY + SCIENCE + INNOVATION

Maximum Performance Series

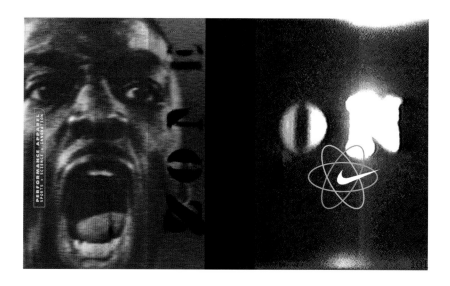

PERFORMANCE APPAREL
SPORTS + SCIENCE + INNOVATION

WICKENS
Do you find yourselves having to collaborate with other agencies or other types of companies?

PARR
Well, collaboration has been a cornerstone of ReVerb from the beginning. It's been easy for us to adapt to working on large projects that require collaboration, because we've been collaborating for years. In the past we've developed creative frameworks that were passed on to agencies to serve as inspiration and guidance. Our current work includes more direct interaction in the form of reviews and strategic discussions about conceptual positioning and visual identity development.

KIM
We often function as a hub for project teams. Some of that happened throughout the years because we were being pulled into projects that involved media that was new to us. When we went into a new area, we would work with teams from different disciplines. Working on the early architecture projects and on film production, we developed a real understanding of teamwork.

NUGENT
I think there are also different levels of collaboration. There's one level involving everyone from writers to film makers to architects...

PARR
And there's another level that involves the client and the client's partners, so that it's...

KIM
An inside/outside, team-building exercise.

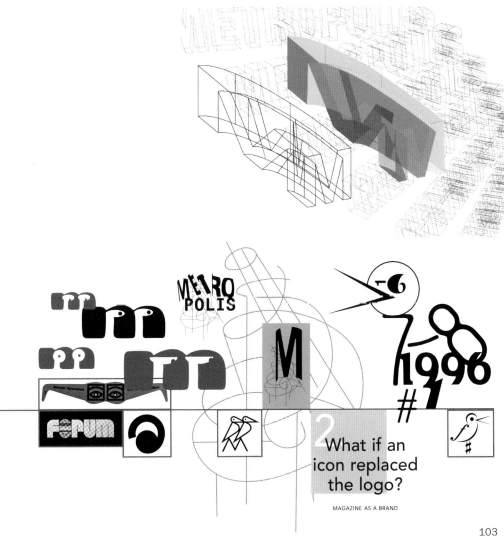

METRO POLIS

M

-6

1996 #1

2 What if an icon replaced the logo?

MAGAZINE AS A BRAND

NUGENT

I think in the partnerships with outside talent, we have always been successful. The hurdle that we're finding as we begin to collaborate with our client's partners is how to built a team that's not competitive, where everybody at the table sees each other as adding value to the process. The more we do it, the more we're finding a common language and a way that people can successfully fit together.

WICKENS

To what extent does ego play a role in a small organization like ReVerb. When I think of the more traditional design companies of yesteryear that were built around several egos, I wouldn't necessarily describe them as collaboratives. ReVerb seems to be very much about team-based innovation, yet clearly, everyone here has a passion, an ax to grind, a story to tell. Does ego play a role at all, or do you have to leave it at the door and really come together as one?

KIM

I think that there's always ego involved, because that's just an integral part of one's personality, one's identity. What we've always shared is an interest in coming up with solutions that we couldn't have come up with on our own. We recognize this interplay between the various minds involved on a project. We may not always agree, but it's not about building consensus. It's about finding the thing that really speaks to whatever the question is that we think we should be answering.

WICKENS

What happens when you don't agree?

KIM

We get cranky.

(Laughter)

Tangram

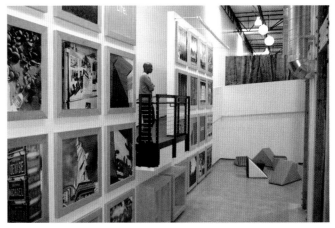

Black: Authentec by Architex: Onyx

Seam mark for these pieces

Grey: Spinneybeck AD 6008

WICKENS

Do you divide the work, or is it equal ownership on every project?

PARR

Well, it depends on the project's size. We each act as team leaders for some projects. With more strategic projects, the three of us distill all the information and solve the problem together. We enjoy what someone else has to bring to the process and what happens when it's all mixed up.

NUGENT

The team will all sit around this table and look at the research. Someone will pull out information that we have about the client or their internal structure and say, "Well, if this is true, then how can this be true?" The complexity of a corporation or a product generates a mountain of information no one person can figure out. It takes looking at it from all perspectives to distill it into one idea that rings true for the corporation, the audience, and the time we live in. We're able to get over the hurdle of ego this way.

KIM

It's usually a formative debate, where we test ideas, and while we all definitely have strong opinions, we also see how and when something is not working. We're willing to recognize that and not hold onto something just because it was our own idea.

NUGENT

On a visual level, I think we share the same aesthetic. I can't think of when we have ever had a significant disagreement.

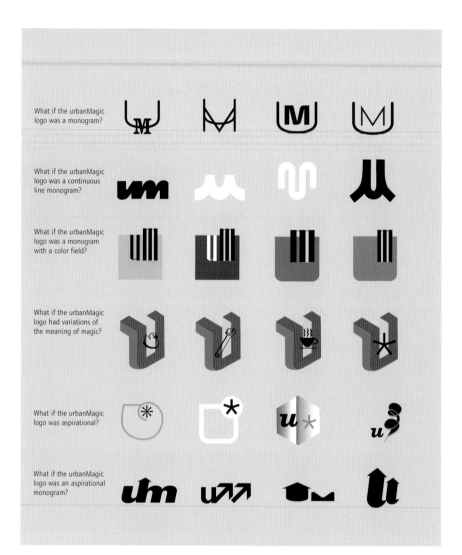

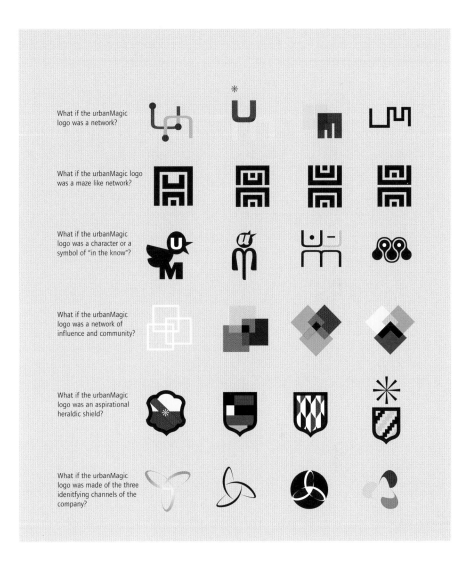

What if the urbanMagic logo was a network?

What if the urbanMagic logo was a maze like network?

What if the urbanMagic logo was a character or a symbol of "in the know"?

What if the urbanMagic logo was a network of influence and community?

What if the urbanMagic logo was an aspirational heraldic shield?

What if the urbanMagic logo was made of the three idenitfying channels of the company?

instinct

twinkle

everywhere

oasis

WICKENS

Let's talk about form. It's usually apparent to me when I'm looking at a piece of ReVerb work, even though the body of your work is remarkably diverse. There's an interesting blend of styles that are futuristic and nostalgic, European and American.

KIM

It relies a lot on juxtaposition. Some of that comes from living in Los Angeles, where things are always bumping up against each other, and depending on what you happen to frame when you look out, you can come up with really interesting combinations of things. I think we also share a deep curiosity about things that are going on in the world, not just locally or in design. We really enjoy looking at what's happening in pharmacology, for instance, or at the pop culture of different countries, or at interesting phenomena that are just part of living in the twenty-first century.

PARR

Finding depth in our form-making has evolved into a role as idea translators. Since our roots are in visual expression, that's how we process information. It's one thing to generate an abundance of eclectic research and form. It's another to orchestrate a communication that's relevant to a particular audience at a particular moment in time. We're fascinated with the impact of changing audience contexts and the challenge of creating form that nevertheless has staying power.

Medicines for Malaria Venture

G.A.S.

www.net**aid**.org

S2

WICKENS

You mentioned earlier that content development has become more important in your work. How do you define "content"?

KIM

Looking back at our history, there was a moment when we realized that we weren't getting briefed anymore and that people were asking us to develop briefs. That seemed like a wonderful breakthrough into working with companies and clients on a higher level.

PARR

Well, this year we produced a book for IBM that celebrated their commitment to diversity in the workplace over the last one hundred years. Their archivist supplied historical material, but in order to make the book's message more relevant, we proposed that the milestones in IBM's diversification be keyed to a timeline charting the company's technological innovations and the current events of the time. This juxtaposition shed light on how IBM's commitment to diversity had actually preceded trends in the marketplace and impacted government policies in a positive way.

KIM

We're walking out into this new area of content building and seeing how it plays into a company's promise. Creating a coordinated brand expression with so many points of contact between companies and consumers requires a new understanding of what content is, supported by research and a strong editorial commitment. We've found that many researchers out there are focused on usability testing or product development, and that research in support of a branding initiative requires a different mind-set and approach.

... and shapes the creative thinking of our innovators.

"Men and women will do the same kind of work for equal pay. They will have the same treatment, the same responsibilities and the same opportunities for advancement."

Thomas J. Watson Sr., 1935

"It is the policy of this organization to hire people who have the personality, talent and background necessary to fill a given job, regardless of race, color or creed."

Thomas J. Watson Jr., 1953

"In order to serve markets, we have to understand them, reflect their diversity, and build a workplace in which every individual knows their opportunity to contribute is gated only by the quality of their ideas and job performance, and the integrity of their work."

Louis V. Gerstner Jr., 1994

IBM

"I had heard about IBM long before I joined the company. When I worked on an Urban League project in high school, I learned about IBM. An executive at the league referenced IBM with such great respect. When I looked at IBM's corporate identity, its principles and practices, **I knew I could be successful there.**"

Nancy Stewart, Vice President, Information, Corporate Enterprise Function, White Plains

Women In Business . . .

"Everybody's talking about better [...] better [...] their own expectations at ESC."

1965
IBM supports Rodman Job Corps Center, an Office of Economic Opportunity project in New Bedford, Massachusetts, which trains 1,200 unemployed youth on, among other things, the IBM 1401 Computer

1966
Benefits offering enriched to include Special Care for Children

Surgical Plan added to IBM's Benefit Plan

1967
Benoit Mandelbrot, physicist at IBM Research, publishes a paper in *Science* relating to fractal geometry [...]

1957
IBM revolutionized programming with the introduction of FORTRAN (Formula Translator). Created by a team working in parallel, John Backus, it soon becomes the initial widely used simple programming language for technical work [...]

1958
IBM employee Michael Supa receives Citation for Meritorious Service from the President's Committee on Employment of the Handicapped

IBM starts paying full-time employees on salary basis instead of an hourly wage

1959
IBM offers employees Tuition Refund Program

Continued individual success

IBM revolutionized programming in the 1950s with the introduction of FORTRAN (Formula Translator), which quickly became the most widely used computer programming language for technical work.

Frances Allen joined IBM in 1957 and was assigned the task of teaching the newly developed programming language to research scientists. Fascinated with the new language, she immersed herself in this area and later received notable, if humorous recognition for her efforts. "My first IBM award in 1968," she recalls, "was a check, a certificate, cuff links and a tie clasp." She went on to collaborate with other women scientists on the Stretch-Harvest, ACS (Advanced Computer System) and PTRAN (Parallel Translation) projects, developing new algorithms and techniques, publishing numerous papers and shaping the history of computing technology.

A member of the National Academy of Engineers, Allen became IBM's first woman IBM Fellow in 1989 and was inducted into the Women in Technology International Hall of Fame in 1997. Having witnessed the profound contributions that women made to the field of computer science in its earliest stages, Allen maintains a commitment to increasing opportunities for women in technology. "Today I mentor women and work hard to recruit them," she says. "We're continuing to make great progress in recruiting and promoting women by mentoring them and helping them become productively engaged in their work. A former student of mine, Anita Borg, founder of System; the Grace Hopper Conference; and the Institute for Women and Technology has become an inspiration for me. One woman plus today's technology plus the right vision can make a huge difference for everyone everywhere."

111

WICKENS

We talk about the Industrial age, the information age, the entertainment age. I'm interested to know where you think we are in terms of the age we're in. Are we still in one of those, or a blend of those, or is something new happening? For me, the 1990s was the era of entertainment, information as entertainment, everything as entertainment. Interesting things went on, all very much about hype. Do you think that we're entering a new era, one that's built first and foremost around content, and then second, around content's delivery, as opposed to just hype?

KIM

It appears to be a real mix. On the one hand, we're so time-poor that we really want to find what we need when we need it; the right content—the right information—to help us get through the day. On the other hand, work and play are so integrated that we don't really see the divisions clearly. I think that there is still a huge interest in entertainment, but it's not entertainment independent of information or of other functionality.

WICKENS

Do you think it's something more than a delivery mechanism, because entertainment existed almost for its own sake for a while?

PARR

Like what happens when, you know, when all five hundred channels of your TV are full?

(Laughter)

WICKENS

The five-hundred channel things has led to putting power into the hands of the consumer. The invention of things like Tivo and Re-play TV, which enable viewers to create their own networks, has had a really profound impact not only on the content that comes from the providers, but also on the advertisers, because these mechanisms have built-in functionality to bypass advertising. So, if televisions eventually have hard drives

and offer viewers the ability to construct their own viewing experience out of whatever comes into their TV, and they have the ability not to see any of the advertising, what value does advertising suddenly have? How might advertisers respond to that?

KIM
As information and entertainment have become more customizable, there has been a greater interest in really understanding the person who is doing the customizing. If you're going to bypass the advertising, well, when are you going to do that? Or what will prevent you from doing that? There is a lot of exploration around interactive TV right now. It's kind of the Holy Grail. How do you get the program to extend beyond? There are lots of different things that media companies do to try and keep people engaged in a story outside the moment when it's on. There are some children's programs that will actually call you up.

NUGENT
One thing we all found interesting coming back from doing field research in Finland and Japan was that with all the new technology and the hundreds of services being offered through mobile phones, most of the usage is text messaging to family and friends—people saying, "Hi. How are you," the most simple human connections.

PARR
Very personal.

NUGENT
Maybe that's what our new content is going to be about, just being in touch with family and friends.

IBM

warning: objects in future are closer than they appear

summer jam 99

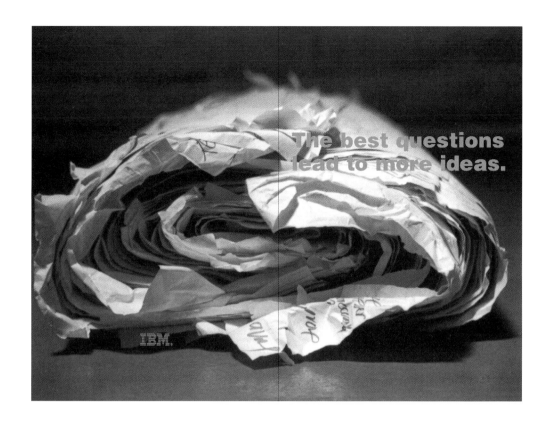

The best questions lead to more ideas.

IBM.

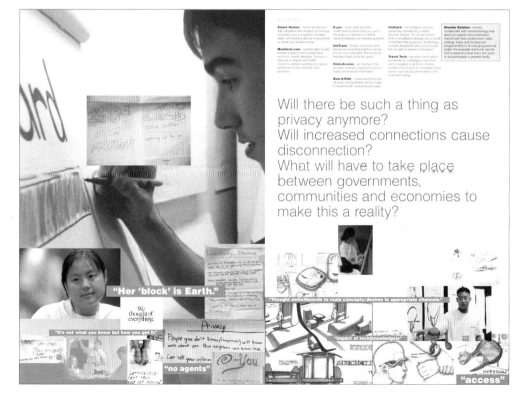

Smart Homes—home architecture fully integrated with wireless technology including voice recognition, movable walls, self-cleaning and an environment to create any desired mood.

Monitech.com—undetectable health monitor implants that connect and record to central database. Service is directed to elderly, with health concerns, athletes wanting to improve performance and prenatal care providers.

E-you—smart toilet provides health monitor every time you use it. Information is stored in a central medical database for monitoring health.

UniTrans—forms communication barriers by providing real-time translation for voice and print. This universal translator helps unite the world.

Omni-Access—an interface that provides seamless, secure access to highly personalized information.

Bum-A-Ride—customized personal all-terrain transportation vehicles able to traverse both land and seascapes.

UniCard—consolidates services previously provided by multiple devices. Slogan: "It's all about this!" 65% of all global marriages are a result of UniCard dating service. Technology includes fingerprint and voice recognition as well as wireless holograms.

Travel Tech—provides travel advice worldwide for multilingual customers and is installed in all forms of trans-portation for access to immediate travel advice such as accommodation and restaurant ratings.

Drexler Estates—homes constructed with nanotechnology that gives occupants voice-command control over their environment: walls, ceilings, floors and furniture are programmable to changing personal tastes. For example, the home can be told to expand a level every five years to accommodate a growing family.

Will there be such a thing as privacy anymore?
Will increased connections cause disconnection?
What will have to take place between governments, communities and economies to make this a reality?

"Her 'block' is Earth."

We thought of everything.

"It's not what you know but how you get it."

"no agents"

"Thought switchboards to route concepts/desires to appropriate channels."

"Impact of tech(knowledge)y"

"access"

115

WICKENS
Why not use your cell phone to talk to the person, rather than typing text messages out on the key pad? You talk about that as being "very personal," when it's almost impersonal.

PARR
It's the new personal.

NUGENT
Technology is facilitating a reinvention of communication and community and is allowing us to relate to each other in new ways. You can travel a great distance or be in the middle of a meeting and yet be reachable via text messaging. That's when it becomes personal, because you're connecting with someone close to you in a new situation.

PARR
It also creates new ways of intimacy. Someone can send a message that they wouldn't necessarily want to deliver over the phone. We found that men in Finland, who are notoriously silent, have embraced cell phones and text messaging because it allows them to NOT talk; they can send something very intimate in a new way.

WICKENS
And feel comfortable doing so?

PARR
Yes, in a totally new way.

KIM
In Japan, which is such a formal, hierarchical society, kids really enjoyed being able to get to who they wanted to speak with immediately, without having to go through a gate-keeper. If they called the landline phone at home, they would have to talk to their friend's parents. So cell phones are creating these short-cuts and ways to bypass more traditional ways of communicating.

(In Helsinki) a man buys thirteen banks while coaching his son's soccer team.

"I keep my phone on all the time, even throughout lunch. Frenchmen hate it."

(In Tokyo) teenage boys transform into mythical warriors before dinner.

"We are Super Deformed Sumo Wrestlers."

NUGENT

It seems that we're in a time when community is the new content. You can play a game on the Internet with somebody and that game is content, but the more interesting content is that connection with somebody on the other side of the planet. More than the game itself, that other person represents the content.

It may also be an era of redefining identity. The networked community offers opportunities to explore multiple identities. A new mom can be a game warrior, as well as an executive manager. In our research, we're interested in learning what motivates people and what captures their imagination. We're often amazed by the person on the street because his or her dreams of the future are so fantastic, beyond anything we would have predicted. These findings inform the positioning directions we explore for our clients.

KIM

Maybe we've entered a new feudal age, with border wars occurring on both global and local levels. Everyone's fighting to own the relationship with the consumer and the client. Many different types of creative agencies are offering services formerly considered outside their scope. Individuals are empowered by multiple channel access, but at the same time, mega-mergers are making it likely that products and media vehicles and delivery systems are all owned by a single company.

PowerPhone
面面通

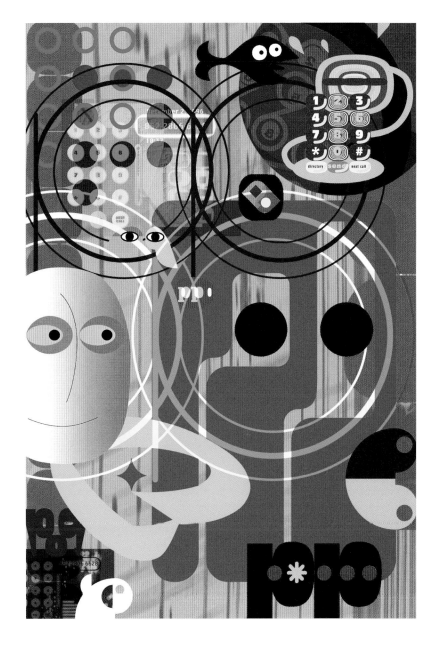

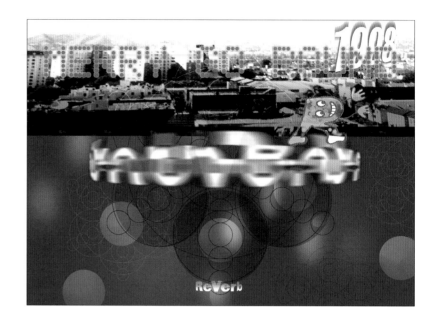

WICKENS

Something that has crossed my mind recently is that the speed of things is actually starting to exceed human scale. The rapidity of communication, information, life, is actually too fast for a lot of people to cope with, so that the need to filter or edit content has increased. I think editing is going to play a larger role in the future, and editors are going to become the new celebrities—or celebrities will become editors. A good example of an editorial brand is Martha Stewart, obviously; a multichannel brand that plays out in a curious range of demographics, from Kmart to the web and everywhere in between. There are all sorts of competitors out there that just lack the editorial machinery, the filtering mechanism, the pass through the eyes and mind of somebody you can trust. They spin out content with no context, no editorial, no believability. A lot of those companies, especially the web companies, are failing, because nobody knows how to connect with them.

PARR

We've seen that, too. People are looking for guides to different lifestyles, for different ways to edit. Take the trend of simplicity, for instance, and how people are seriously looking at how to edit not just information, but their whole life. A kind of control is required. What tools are required to help you exercise this control?

KIM

It seems that companies themselves are trying to play the role of editor, as it becomes more important to have a network or platform and not just a product. In that sense, the brand becomes the editor, or hopes to, so that its customers believe that something coming from that company will fulfill certain expectations. With the Internet making available a vast body of unfiltered content, people will look to trusted brands to help them find what they need.

Solar Eclipse
July 11, 1991
11:28 a.m. p.d.t.
Griffith Observatory

Something may happen with future generations. I watch my nephews, who are eleven and twelve, do a lot of self-editing on line. They are surrounded by endless amounts of entertainment, rated G to X, and are continually faced with making selections. Editing may become so much a part of them that they'll accept editing tools as an invisible and organic process, while we're still thinking about the implications of narrowing the search and the possibility of missing that one random, fantastic discovery.

Credits

Kevin Lyons

x: Fresh Dialogue event invitation, 2000; Client: AIGA

2: "Flores No. 1" poster, Spring/Summer 2000; Client: Urban Outfitters; Art Director: Kevin Lyons; Creative Director: Sue Otto; Designers: Kevin Lyons, Jeremy Dean, Ed Brogna, Lance Rusoff, Jim Richards, Erin Mulcahy

3 left: "Las Fruitas No. 3" poster, Spring/Summer 2000; Client: Urban Outfitters; Art Director: Kevin Lyons; Creative Director: Sue Otto; Designers: Kevin Lyons, Jeremy Dean, Ed Brogna, Lance Rusoff, Jim Richards, Erin Mulcahy

3 top right: Sticker sheet/location card, Holiday 1999/2000; Client: Urban Outfitters; Art Director: Kevin Lyons; Creative Director: Sue Otto; Designers: Jim Datz, Jeremy Dean, Ed Brogna, Lance Rusoff, Kevin Lyons, Jim Richards

3 top far right: Store location card, Spring/Summer 2000; Client: Urban Outfitters; Art Director: Kevin Lyons; Creative Director: Sue Otto; Designer: Jeremy Dean, Ed Brogna

3 center right: urbn.com announcement postcards #1 and #2; Client: Urban Outfitters; Art Director: Kevin Lyons; Creative Director: Sue Otto; Designers: Jeremy Dean; Illustrator: Ed Brogna

3 bottom right: In-store employee badges, Holiday 1999/2000; Client: Urban Outfitters; Art Director: Kevin Lyons; Creative Director: Sue Otto; Designers: Jeremy Dean; Illustrator: Ed Brogna; Photography: Lance Rusoff

4: Double-label tee-shirt advertisement, 2000; Client: Supreme; Publisher: *Tokion* magazine

5 top left: Double-label tee-shirt advertisement, 1999; Client: Mooks; Publisher: *Tokion* magazine

5 top right: Double-label tee-shirt advertisement, 1999; Client: SSUR; Publisher: *Tokion* magazine

5 bottom left: Subscription offer page, 1999; Publisher: *Tokion* magazine

5 bottom right: Double-label tee-shirt advertisement, 1999: Client; Stussy; Publisher: *Tokion* magazine

6: Annual Report, 2000; Client: Urban Outfitters, Inc; Art Director: Kevin Lyons; Creative Director: Sue Otto; Designers: Lance Rusoff, Erin Mulcahy, Kindra Murphy; Illustrators: Scott Minton, Ed Brogna, Jeremy Dean

7: Posters, Holiday 2000/2001; Client: Urban Outfitters; Art Director: Kevin Lyons; Creative Director: Sue Otto; Designers: Erin Mulcahy, Kindra Murphy, Jeremy Dean, Lance Rusoff, Andy Beach

8: "That Which Kills..." tee-shirt graphic, 1998; Client: Nike, Inc.; © 1998, Nike, Inc.

9 left: "Can Not/Will Not Be Denied" tee-shirt graphic, 1998; Client: Nike, Inc.; © 1998, Nike, Inc.

9 top right: "Broken Glass" tee-shirt graphic (front), 1998; Client: Nike, Inc.; © 1998, Nike, Inc.

9 center right: LA 3on3 Basketball Tournament tee-shirt graphic, 1997; Client: Nike, Inc.; © 1997, Nike, Inc.

9 bottom right: "A Woman's Work..." tee-shirt graphic, 1998; Client: Nike, Inc.; © 1998, Nike, Inc.

10 top: Nike Basketball, West Coast Grassroots Division, Summer Basketball League poster, 1999; Client: Nike, Inc.; Designers and Art Directors: Kevin Lyons and Beth Elliott; Photography: Cliff Watts; © 1999, Nike, Inc.

10 bottom: "Broken Glass" tee-shirt graphic (back), 1998; Client: Nike, Inc.; © 1998, Nike, Inc.

11: Fourstar tee-shirt graphic, 1998; Client: Girl Skateboards

12: "Show No Love" tee-shirt graphic, 1998; Client: Nike, Inc.; © 1998, Nike, Inc.

13 top: Fourstar tee-shirt graphic, 1998; Client: Girl Skateboards

13 bottom: Fourstar tee-shirt graphic, 1998; Client: Girl Skateboards

14 top left: Mystic sticker, 1999; Client: Natural Born

14 top right: Marching Soldiers logo, 1997; Client: Natural Born; Designers: Russell Karablin and Kevin Lyons

14 middle: Stepping Razor sticker, 1999; Client: Natural Born

14 bottom left: Zapata sticker, 2000; Client: Natural Born

14 bottom right: "Military Minded" tee-shirt graphic, 2000; Client: Atlantis

15: Subscription offer page, 2001; Publisher: *Tokion* magazine

16: Rebel Ape offset poster (front), 1999; Client: SSUR, Inc.; Rebel Ape concept and logo: Russell Karablin, based on a painting by Russell Karablin; Art Director: Russell Karablin and Kevin Lyons; Designers: Russell Karablin and Kevin Lyons; Layout and Separations: Kevin Lyons; Type Design: Kevin Lyons

17: Rebel Ape offset poster (back), 1999; Client: SSUR, Inc.; Concept and Art Director: Kevin Lyons; Designer: Kevin Lyons; Layout and Separations: Kevin Lyons

18: Camouflage Word series, silk-screened on tee-shirts, 1998; Client: SSUR, Inc.; Concept and Initial Art Director: Russell Karablin; Art Director and Designer: Kevin Lyons

19 top and middle: Color By Numbers Camo Flyer (back and front), 1998; Client: SSUR, Inc.

19 bottom: SSUR PLUS Kong business card, 2000; Client: SSUR, Inc.

20: Tee-shirt images, 2000; Client: Brand Jordan, Inc.: © 2000, Brand Jordan, Inc.; Copywriter: Kevin Lyons

21: "Orange Rims (No Longer)..." tee-shirt graphic (front and back), 1998; Client: Nike, Inc.; © 1998, Nike, Inc.

22: Adidas Street Basketball logos #1, #2, #3 and #4, 2001; Client: Adidas, Inc.; Project Director: Mike Klein, Adidas U.S.; © 2001, Adidas, Inc.

23: Adidas Street Basketball tee-shirts, 2001; Client: Adidas, Inc.; Project Director: Mike Klein, Adidas U.S.; © 2001, Adidas, Inc.

24: "US vs. Them/Vernacular" silk-screened tee-shirt graphic (back and front), 1996; Project: CalArts graduate thesis, "The Low End Theory: Extremity of Rhythm"

25 top: "Build & Destroy/The Next Shit" silk-screened tee-shirt graphic (back and front), 1996; Project: CalArts graduate thesis, "The Low End Theory: Extremity of Rhythm"

25 middle: "Whirlwind Kicks/Undermine" silk-screened tee-shirt graphic (back and front), 1996; Project: CalArts graduate thesis, "The Low End Theory: Extremity of Rhythm"

25 bottom: "Much Respect Due/Cut N' Mix" silk-screened tee-shirt graphic (back and front), 1996; Project: CalArts graduate thesis, "The Low End Theory: Extremity of Rhythm"

26: Carlos Rosas silk-screened poster, 1995; Client: CalArts Visiting Artist Lecture Series; Designers: Kevin Lyons and Geoff McFetridge

27 top left: Jim Shaw silk-screened poster, 1996; Client: CalArts Visiting Artist Lecture Series

27 top right: Thomas Starr silk-screened poster, 1996; Client: CalArts Visiting Designer Lecture Series

27 bottom left: Douglas Crimp silk-screened poster, 1995; Client: CalArts Visiting Artist Lecture Series; Designer: Kevin Lyons and Geoff McFetridge

27 bottom right: Smog Design silk-screened poster, 1996; Client: CalArts Visiting Designer Lecture Series

28: Various tee-shirt graphics, 1999; Client: Stussy, Inc.

29 top: Tee-shirt graphic, 1999; Client: Stussy, Inc.

29 bottom: Double-page advertisement, 1999; Client: Stussy, Inc.

30: Back To School and urbn.com stickers (unpunched on sheet), 2000; Client: Urban Outfitters; Art Director: Kevin Lyons; Creative Director: Sue Otto; Design and Illustration: Ed Brogna; Additional Type Design: Jeremy Dean

31 top: Double-page advertisement, 1999; Client: Stussy, Inc.

31 bottom left: "Dream 1999" Summer Basketball Swoosh League poster, Nike Basketball, West Coast Grassroots Division, 1999; Client: Nike, Inc.; Design and Art Director: Kevin Lyons and Beth Elliott; Photography: Cliff Watts; © 1999, Nike, Inc.

31 bottom right: "Prevail 1999" Summer Basketball Supreme Challenge League poster, Nike Basketball, West Coast Grassroots Division, 1999; Client: Nike, Inc.; Design and Art Director: Kevin Lyons and Beth Elliott; Photography: Cliff Watts; © 1999, Nike, Inc.

32: "Welcome Back To School" poster #1, 2000; Client: Urban Outfitters; Art Director: Kevin Lyons; Creative Director: Sue Otto; Designers: Kindra Murphy, Erin Mulcahy, Andy Beach, Lance Rusoff, Jeremy Dean

33: "Welcome Back To School" poster #2, 2000; Client: Urban Outfitters; Art Director: Kevin Lyons; Creative Director: Sue Otto; Designers: Kindra Murphy, Erin Mulcahy, Andy Beach, Lance Rusoff, Jeremy Dean

34 top: Oatmeal Lavender Hemp soap packaging, 2001; Client: Natural Born

34 bottom: Cornmeal Honey Hemp soap packaging, 2001; Client: Natural Born

35: Advertisement #1, 1999; Client: Natural Born

36: Annual Report, 2000; Client: Urban Outfitters, Inc.; Art Director: Kevin Lyons; Creative Director: Sue Otto; Designers: Lance Rusoff, Erin Mulcahy, Kindra Murphy; Illustrators: Scott Minton, Ed Brogna, Jeremy Dean

37 top left: Poster #1, Holiday 1999/2000; Client: Urban Outfitters; Art Director: Kevin Lyons; Creative Director: Sue Otto; Designers: Jim Datz, Jeremy Dean, Ed Brogna, Lance Rusoff, Kevin Lyons, Jim Richards

37 top right: Poster #2, Holiday 1999/2000; Client: Urban Outfitters; Art Director: Kevin Lyons; Creative Director: Sue Otto; Designers: Jim Datz, Jeremy Dean, Ed Brogna, Lance Rusoff, Kevin Lyons, Jim Richards

37 bottom: Annual Report, 2000; Client: Urban Outfitters, Inc.; Art Director: Kevin Lyons, Creative Director: Sue Otto; Designers: Lance Rusoff, Erin Mulcahy, Kindra Murphy; Illustrators: Scott Minton, Ed Brogna, Jeremy Dean

39: Billboard, Los Angeles, 2000; Client: Tokion magazine

Special thanks to Russell Karablin, Adam Glickman at Tokion, and Jens Gehlhaar.

one9ine

40. Fresh Dialogue web site, May 2000; Client: AIGA; Designer: one9ine

43: Graduate Book, Cranbrook Academy of Art, 1999; Designers: Warren Corbitt and Annabelle Gould

45 top: Codex Series CD Rom cover and poster, 1999; Designer: Matt Owens

45 bottom: Codex Series CD Rom cover and poster, 2000; Designer: Matt Owens

46: "See/Self," 1999; Project: Graduate Thesis, Cranbrook Academy of Art; Designer: Warren Corbitt

47: "Stasis/Static" light box panels, 1998; Designer: Warren Corbitt

48-49: ESPN Next Type, 1999; Designer: one9ine; Publisher: *ESPN* magazine

50-51: Destroy Rock City web site, 1999-2000; Designer: Lee Misenheimer

53: whatever.nike.com, 1999; Client: Wieden + Kennedy; Designer: one9ine

54 top: Cover, Art and Design Issue, 1999; Client: *Punk Planet*; Designer: Matt Owens

54 middle and bottom: "Arrival/Departure" postcards, 1999; Designer: Matt Owens

55: IMG SCR 100 spread, 1999; Designer: Matt Owens; Client: IMG SCR 100

56-57: "Implicit proportion," 2000; Publisher: Remedi Project; Designer: Warren Corbitt

58: "Sweet 16," 1997-2001; Client: volume-one.com; Designer: Matt Owens

59 top left and right: "Assembly Lines," 1999; Client: volumeone.com; Designer: Matt Owens

59 middle: "Sweet 16," 1997-2001; Client: volumeone.com; Designer: Matt Owens

59 bottom left: Cover, Spring 1999; Client: volumeone.com; Designer: Matt Owens

59 bottom right: Cover, Autumn 1999; Client: volumeone.com; Designer: Matt Owens

60: dot.jp, 2000; Client: Museum of Modern Art; Designer: one9ine

61 top and middle left: "Masterpieces from the Vitra Design Museum: Furnishing the Modern Era," 2000; Client: Cooper Hewitt National Design Museum; Designer: one9ine

61 bottom left: "The Opulent Eye of Alexander Girard," 2000; Client: Cooper Hewitt National Design Museum; Designer: one9ine

61 top and bottom right: "Modern Art Despite Modernism," 2000; Client: Museum of Modern Art; Designer: one9ine

62 top: "Periphery," 1998; Publisher: *Ray Gun* magazine; Designer: Warren Corbitt; Photographer: Dana Menussi

62 middle: "Smiley Smile: Fat Boy Slim," 1998; Publisher: *Ray Gun* magazine; Designer: Warren Corbitt; Photographer: Dana Menussi

62 bottom: "Kiss," 1998; Publisher: *Ray Gun* magazine; Designer: Warren Corbitt; Photographer: Dewey Nicks

63: "Style," 1998; Publisher: *Ray Gun* magazine; Designer: Warren Corbitt; Photographer: Kelly Rierson

64-65: Spread, 2001; Client: The Alternative Pick; Designer: one9ine

66-67: Bartle Bogle Hegarty web site, 2000-2001; Client: Bartle Bogle Hegarty; Designer: one9ine

68: *Cover*, 1999; Client: *IdN* magazine; Designer: Matt Owens

69: "I Love You This Much Gia," 2001; Publisher: Thirsttype; Designer: one9ine; Editor: Patric King

70: "Terrafirma," 1997-2001; Client: volume-one.com; Designer: Matt Owens

71 top: "Achilles Young Achiever," 1997-2001; Client: volumeone.com; Designer: Matt Owens

71 bottom: Cover, Summer 2000; Client: volumeone.com; Designer: Matt Owens

72-73: "Deep End" spreads, Summer 1999; Client: *Emigre* magazine; Designer: Matt Owens

74 top: Cover, Winter 2001; Client: volumeone.com; Designer: Matt Owens

74 bottom and 75 bottom: "Interventions, a study," 1997-2001; Client: volumeone.com; Designer: Matt Owens

75 top: "Consumer/Perceived," 1997-2001; Client: volumeone.com; Designer: Matt Owens

76 top: "The Arena of the Future," 1999; Publisher: *ESPN* magazine; Designer: one9ine

76 bottom: "The Sport of the Future," 1999; Publisher: *ESPN* magazine; Designer: one9ine

77: "The Shoe of the Future," 1999; Publisher: *ESPN* magazine; Designer: one9ine

78: Identity explorations, 1999; Client: Sci Fi Channel; Designer: one9ine

79: Oratai: DSR17, 1999; Client: Skooby Laposky; Designer: Warren Corbitt; Photographers: David Crabb and Warren Corbitt

80-81: "New Leaf," 1997-2001; Client: volume-one.com; Designer: Matt Owens

ReVerb

82: Fresh Dialogue presentation opener, 2000, ReVerb; Client: AIGA

84 top: Toothy R, 1993; Client: ReVerb

84 bottom: Floor plan of original workspace, ReVerb, 1990

85: Thai Type, 1998; Client: ReVerb

86: "Target Consumer Interview" idea book spreads, 1997; Client: MTV

87 top: "Channel Audit" idea book, 1997; Client: MTV

87 bottom left and right: "Media Landscape Comparison" idea book, 1997; Client: MTV

88: "Barometer Reading: Conversations with 10 Consumers" consumer technology profile, 1999; Client: Hewlett-Packard

89 top: "Nerd" chart, 1999; Client: Hewlett-Packard

89 bottom: "Comfort Levels" chart, 1999; Client: Hewlett-Packard

90: "In Circulation" diagrams, 1997; Project: The Blood Project

91: "In Circulation" spreads, 1997; Project: The Blood Project

92: Image posters, 1997; Client: DEN (Digital Entertainment Network)

93: "Portrait of a Generation" photo bank, 1997; Client: DEN (Digital Entertainment Network)

94-95: Identity and collateral, 2000; Client: Maison 140 Hotel

96-97: Identity and signage, 1999; Client: Avalon Hotel

98-99: Identity, tradeshow booth, and web design, 2000; Client: Metrius

100-101: F.I.T. identity studies, hangtag prototypes, and image framework book cover and spreads, 1997; Client: Nike

102-103: "Championing the Verb" spread details, 1996; Publisher: *Metropolis* magazine

104-105: Identity, posters, furniture schematic, and executive showroom, 1999; Client: Tangram

106-107 top: Identity studies and image book, 2000; Client: UrbanMagic

108: Map detail, 1992; LAX: The Los Angeles Exhibition

109 top: Medicines for Malaria Venture logo, 2000; Client: World Health Organization

109 middle: Landmarks logo, 1997; Client: Getty Conservation Institute

109 bottom left: Logo, 1999; Client: G.A.S.

109 bottom, center left: NetAid logo, 1999; Client: KPMG

109 bottom, center right: S2 logo, 1994; Client: Nike

109 bottom right: Logo, 1997; Client: A&M Records

110-111: "Valuing Diversity: An Ongoing Commitment" brochure spreads and cover, 2000; Client: IBM

112-113: Web site, 1999; Client: NetAid

114-115: Summer Jam 1999 event packaging and report, 1999; Client: IBM

116-117: Executive Briefing Center roaming installation, 2000; Client: Hewlett-Packard

118 top: "Help Screen" touchscreen interface, 1997; Client: PowerPhone

118 bottom: Logo, 1996; Client: PowerPhone

119: Logo studies, 1996; Client: PowerPhone

120 top: New Year's Card, 1998; Client: ReVerb

120 center and bottom: "Cycles of Adoption" diagrams, 2001; Project: Design Forum 2001

121: Cover, 1992: Client: *Now Time* magazine

122: Poster, 1997; Client: SCI-Arc

123: New Year's plate, 2001; Client: ReVerb

ReVerb's extended team of collaborators on some of the projects illustrated in this book includes the following designers, writers, photographers, signage consultants, editors, and other experts: Aaron King*, Alia Malley, Andrew Bush, Andrew Slopsema, Armen Sevada, Azadeh Nashat*, Beth Elliott, Bill Gallery, Bob Losa, Caryn Aono, Christian Daniels*, COA, Dannielle Hernandez*, Danny Clinch, David Harlan, Diane Nugent, Drew Hodgson*, Edward Fella, Edward Nachtrieb, Gail Swanlund, Geoff McFetridge, Gino Lee, Glen Nakasako, Greg Lindy, Grey Crawford, Haven Hartman*, James W. Moore, Jane Bogart, Jennifer Suh*, Jeri Heiden, John Heiden, John Kieselhorst, Kathleen Klein*, Kelly Wearstler, Kristin Dietrich, Larimie Garcia, Marie Reese, Mark Haskell Smith, Mitch Tobias, Miyoshi Barosh, Nancy Kates, Oliver Laugsch, Pej Behdarvand, Rick Reese, Rick Vermeulen, Rie Amaki, Robert Kerssing, Sherri Schottlaender, Sojin Kim, Stone Yamashita, Tom Ramirez, Véronique Vienne, Whitney Lowe, and Winnie Li.

*current ReVerb staff member

Contributors

Kevin Lyons heads the studio Natural Born in New York City. His work for Nike, Adidas, and Urban Outfitters helped forge a bond between local idiom and national marketing strategy. Lyons was interviewd by CalArts classmate Weston Bingham.

Warren Corbitt and Matt Owens formed one9ine in 1995 and since then have extended the reach of good design onto the World Wide Web for clients as diverse as Nike and the Cooper-Hewitt Museum. The partners were interviewed by AIGA Editorial Director Andrea Codrington.

ReVerb, a ten-year-old design consultancy, offers innovative research-based design for corporate giants such as IBM and Sony. Principals Susan Parr, Somi Kim, and Lisa Nugent were interviewed by journalist Brett Wickens.